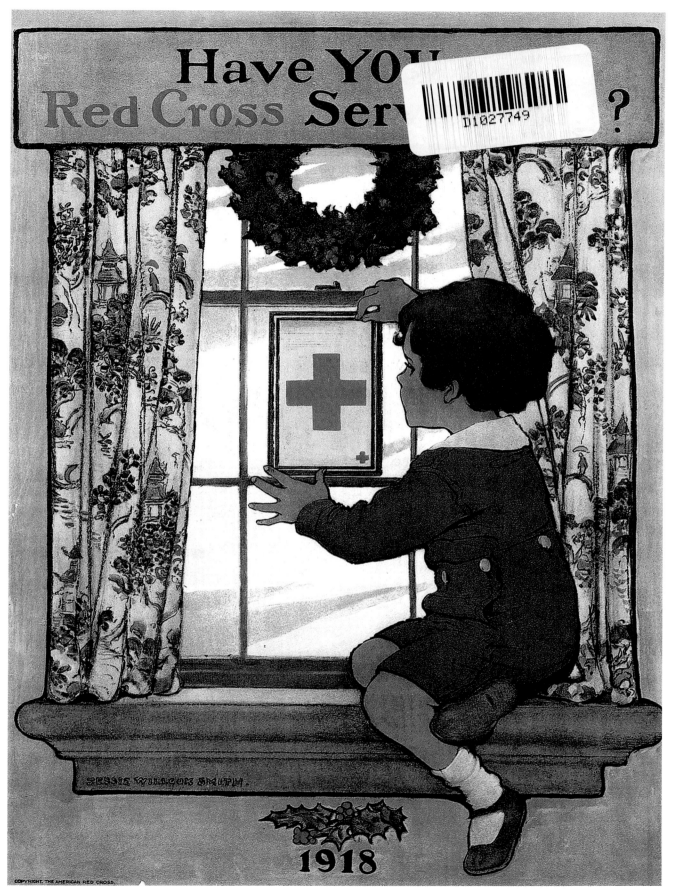

001. Jᴇssɪᴇ Wɪʟʟᴄᴏx Sᴍɪᴛʜ, 1918

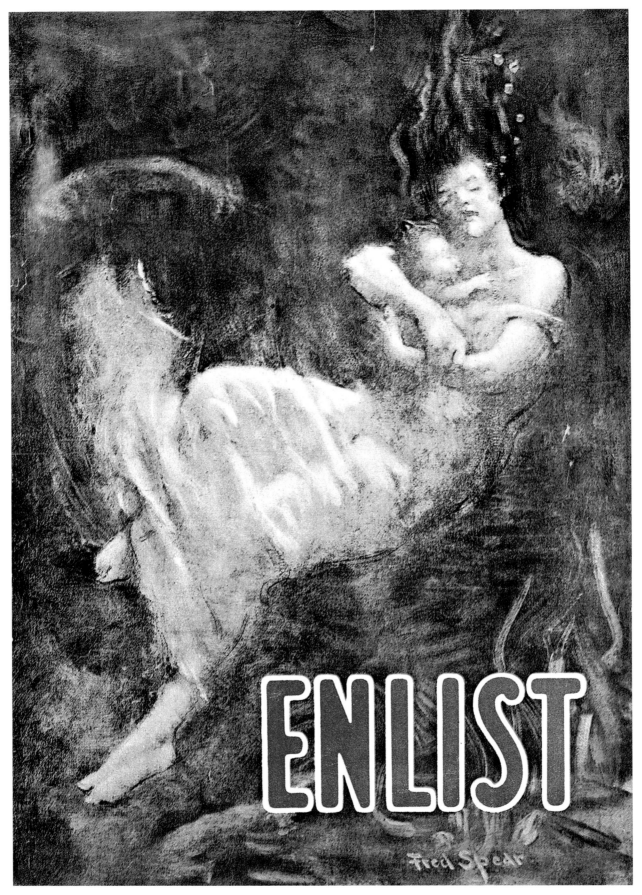

ENLIST

Fred Spear

002. Fred Spear, 1915

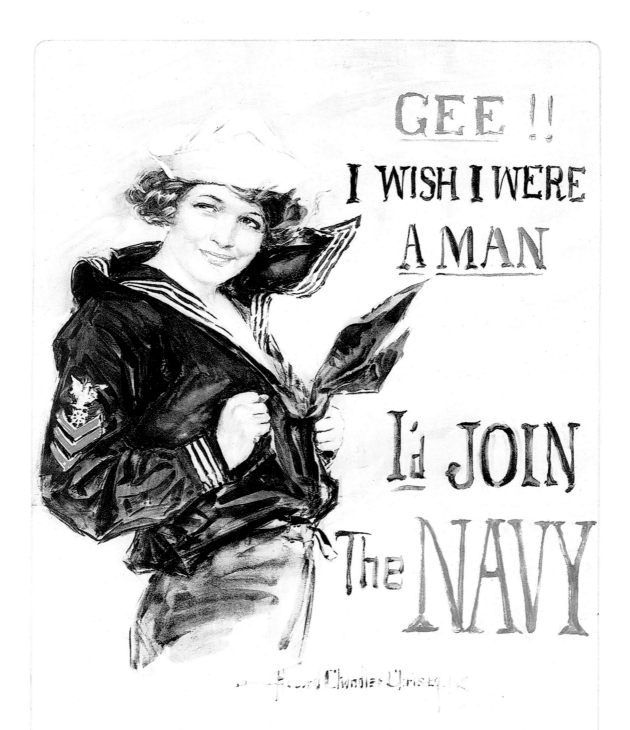

003. Howard Chandler Christy, 1918

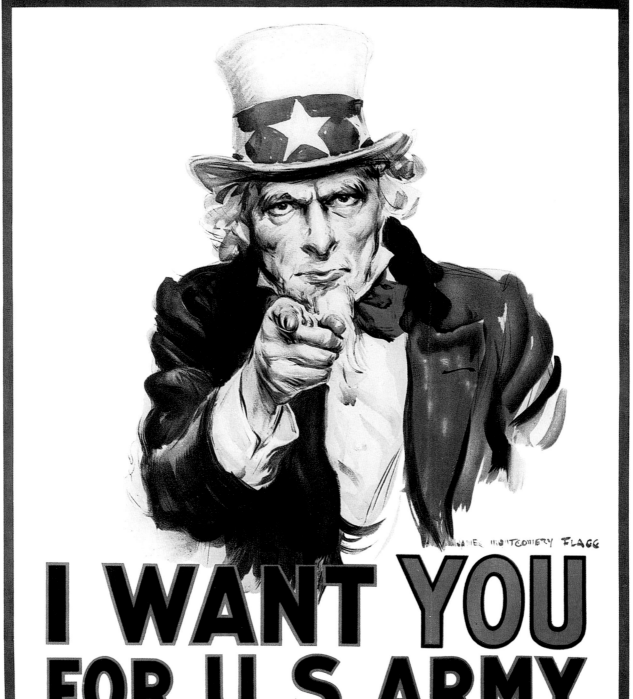

004. James Montgomery Flagg, 1917

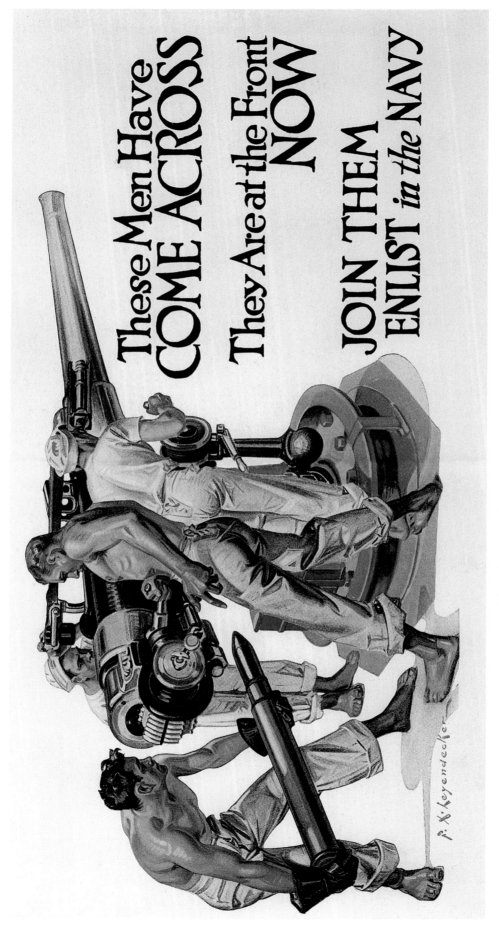

005. Francis Xavier Leyendecker, 1917

006. Herbert Andrew Paus, n.d.

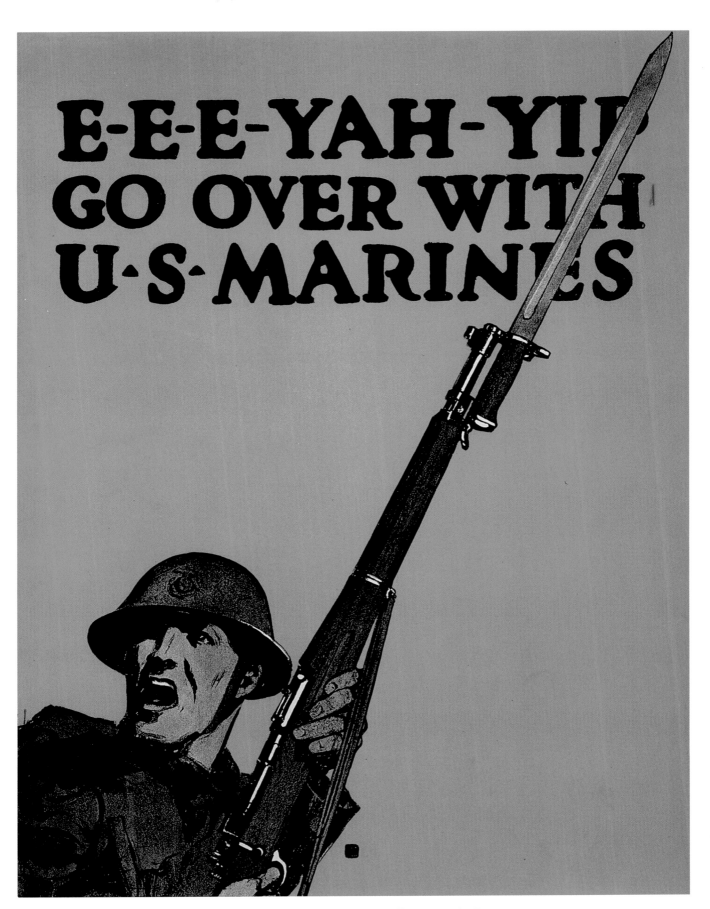

007. CHARLES BUCKLES FALLS, 1917

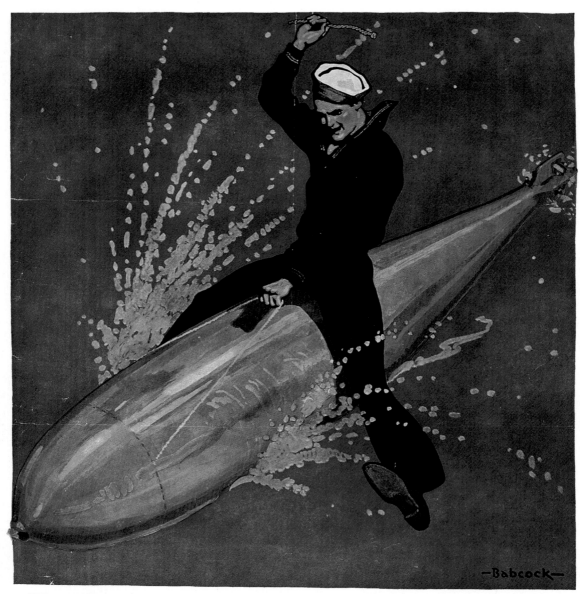

JOIN ≋ THE NAVY
THE SERVICE FOR FIGHTING MEN

008. RICHARD FAYERWEATHER BABCOCK, 1917

009. Arthur N. Edrop, 1917

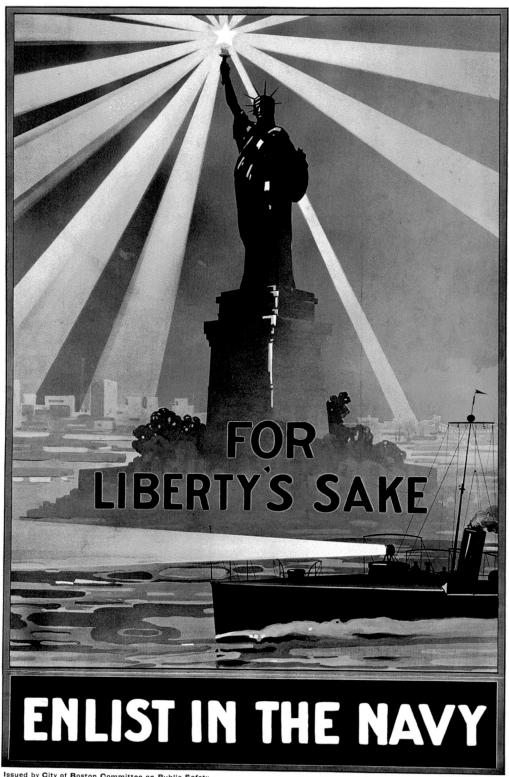

FOR LIBERTY'S SAKE

ENLIST IN THE NAVY

Issued by City of Boston Committee on Public Safety

Smith & Porter Press, Boston

010. ARTIST UNKNOWN, 1917

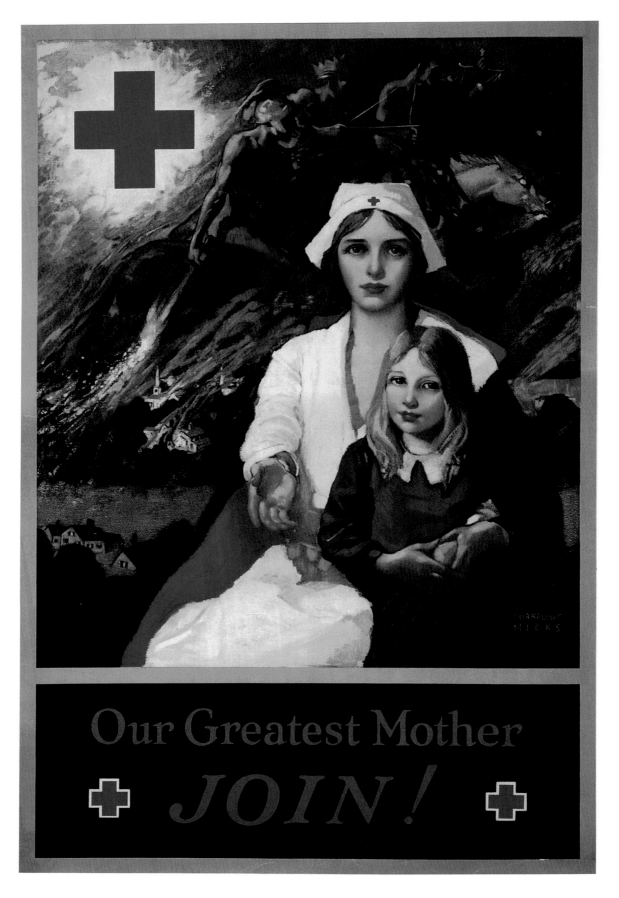

011. Cornelius Hicks, 1917

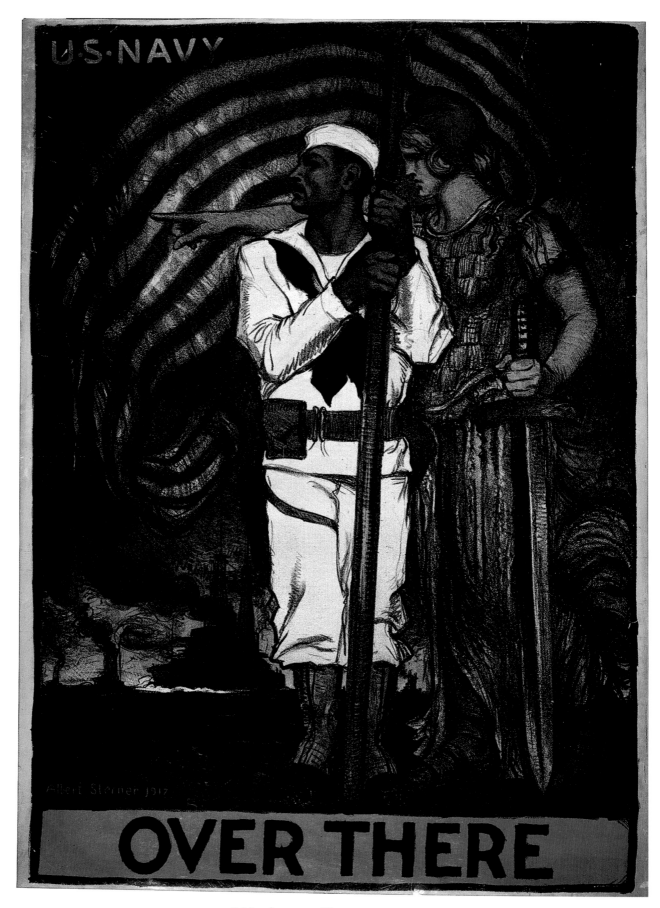

012. Artist Unknown, N.D.

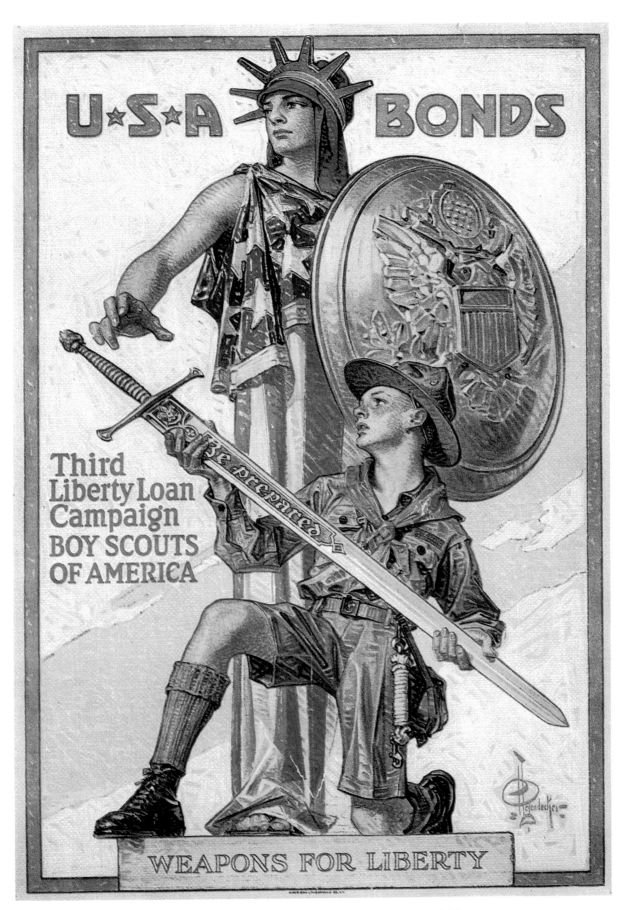

013. Francis Xavier Leyendecker, 1918

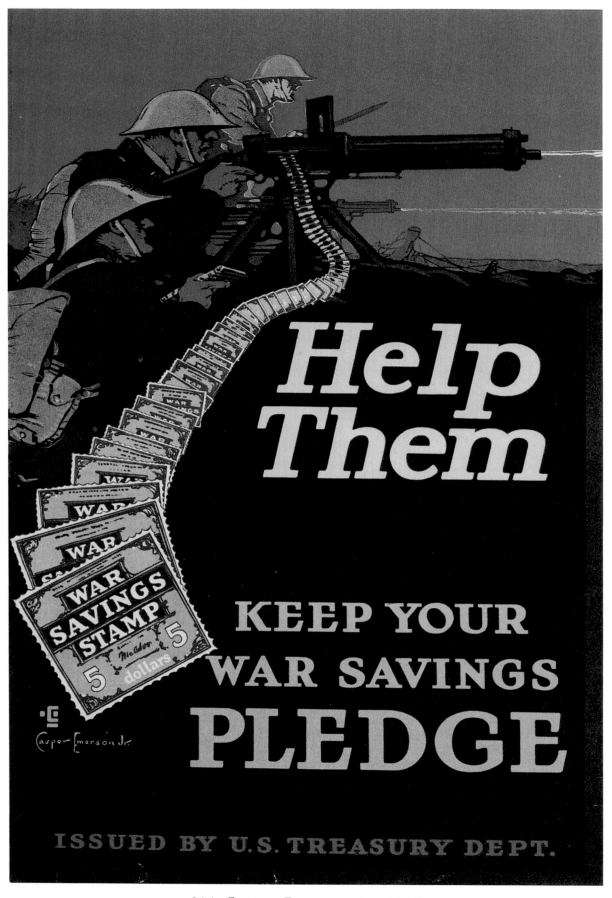

014. Casper Emerson, Jr., 1918

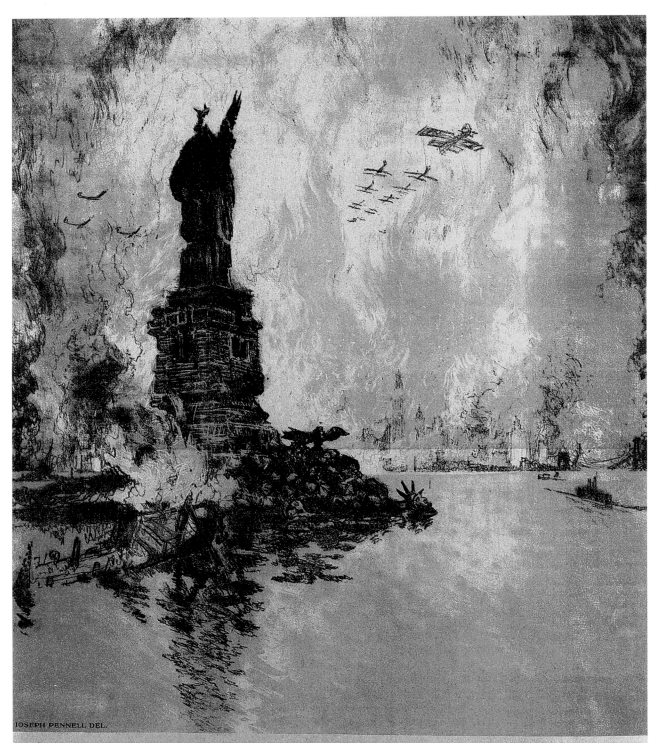

THAT LIBERTY SHALL NOT
PERISH FROM THE EARTH
BUY LIBERTY BONDS
FOURTH LIBERTY LOAN

015. JOSEPH PENNELL, 1918

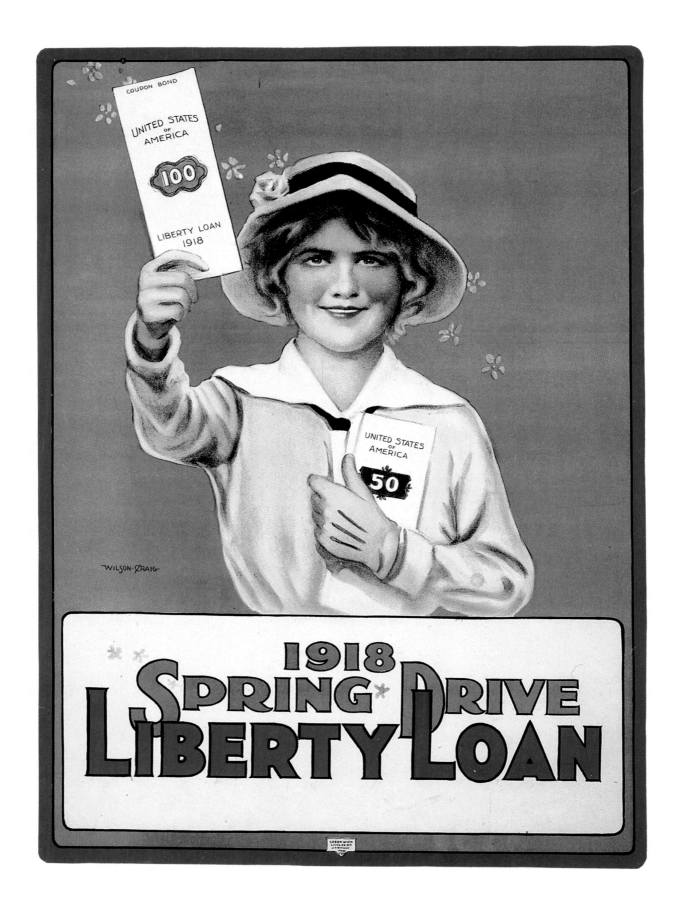

016. Wilson-Craig, 1918

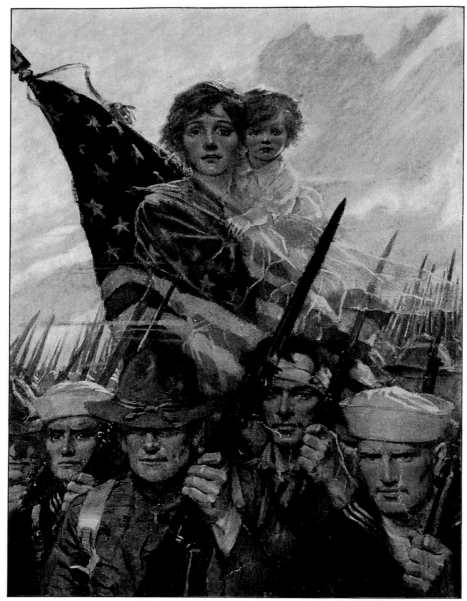

For The SAFETY OF WOMANHOOD
For The PROTECTION OF CHILDHOOD
For The HONOR OF MANHOOD
And For LIBERTY THROUGHOUT THE WORLD

—

HELP 'TILL IT HURTS

—

LIBERTY LOAN COMMITTEE OF WASHINGTON

017. KER, 1918

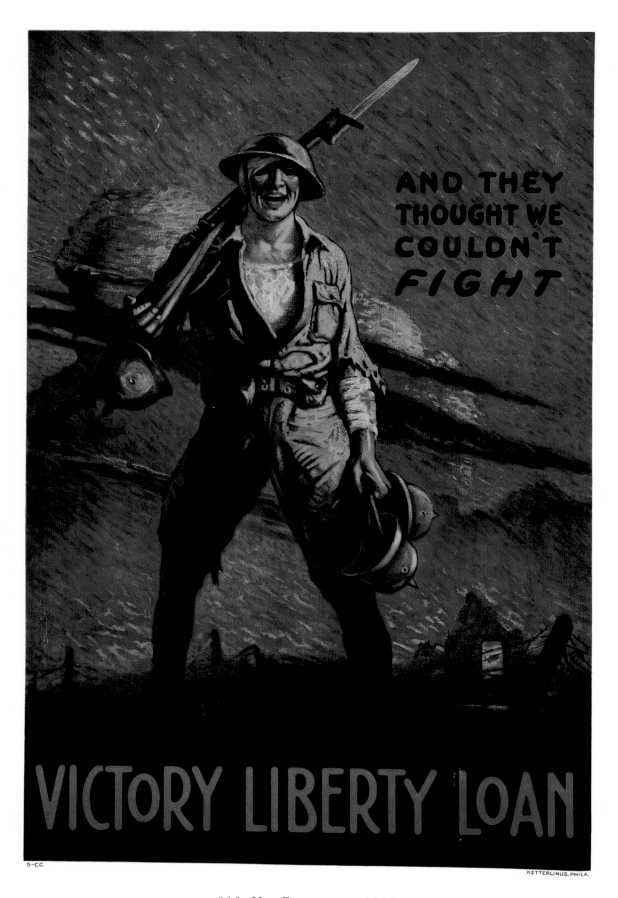

018. Vic Forsythe, 1917

019. Alfred Everitt Orr, 1918

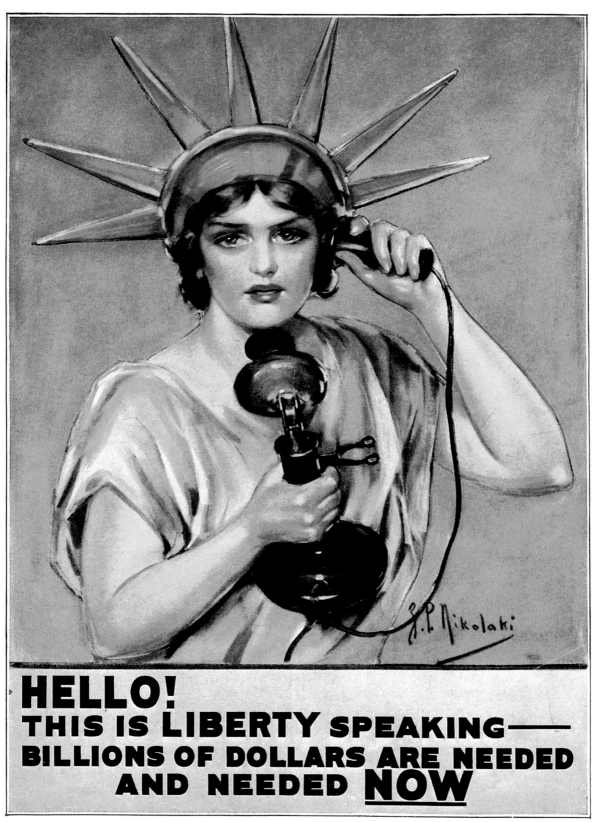

HELLO!
THIS IS LIBERTY SPEAKING—
BILLIONS OF DOLLARS ARE NEEDED
AND NEEDED NOW

Supplement to Engineering & Mining Journal, September 21, 1918.

020. Z. P. Nikolaki, 1918

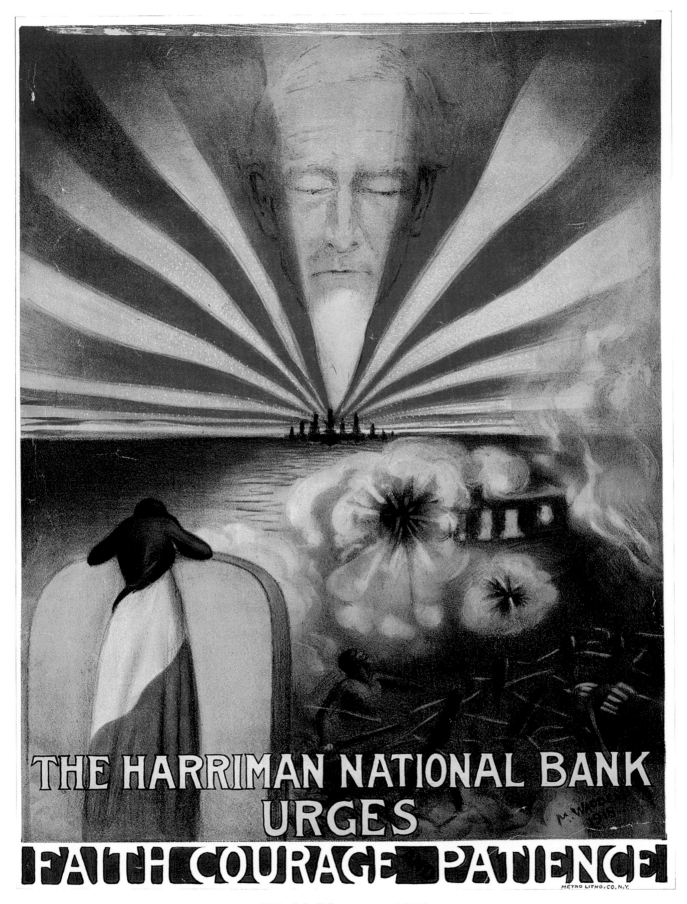

021. M. Waddell, 1918

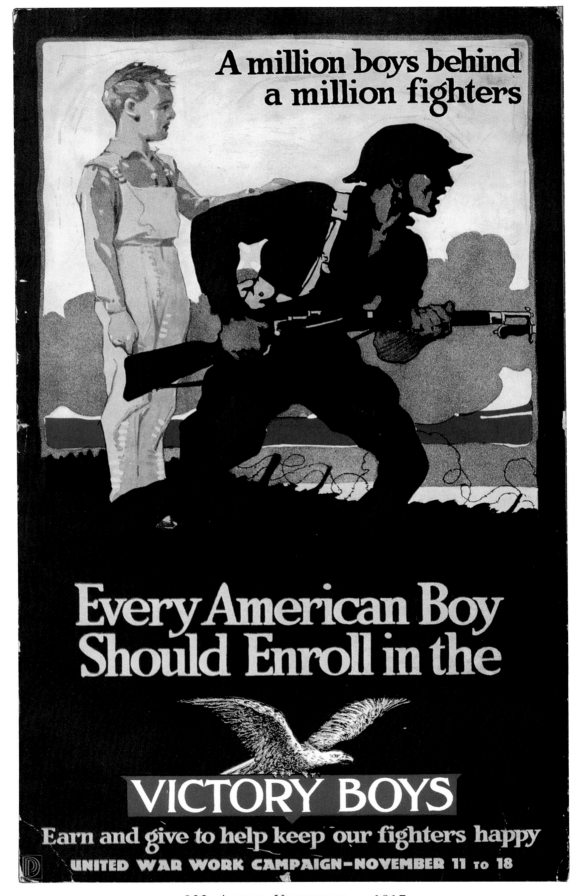

022. Artist Unknown, c. 1917

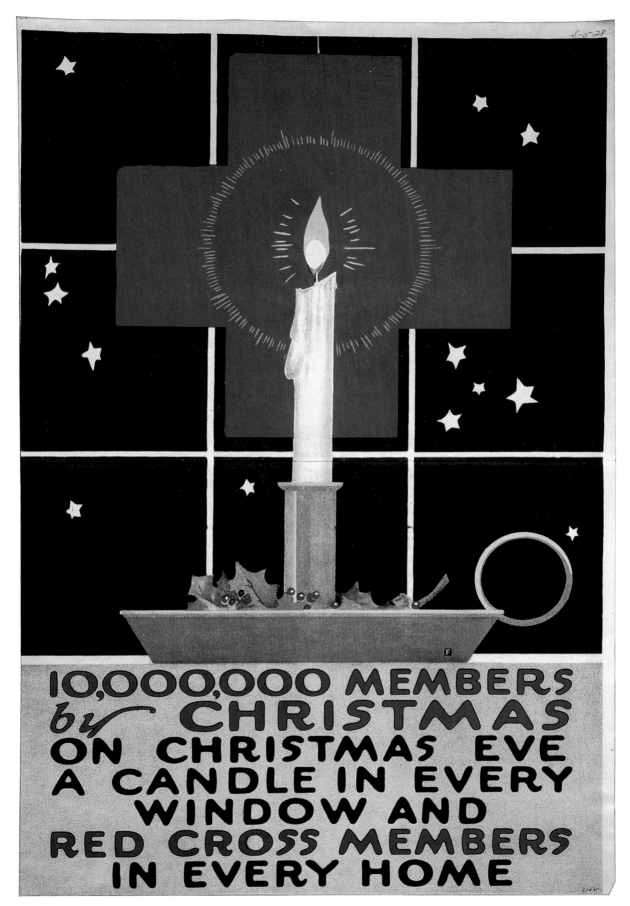

023. Artist Unknown, 1917

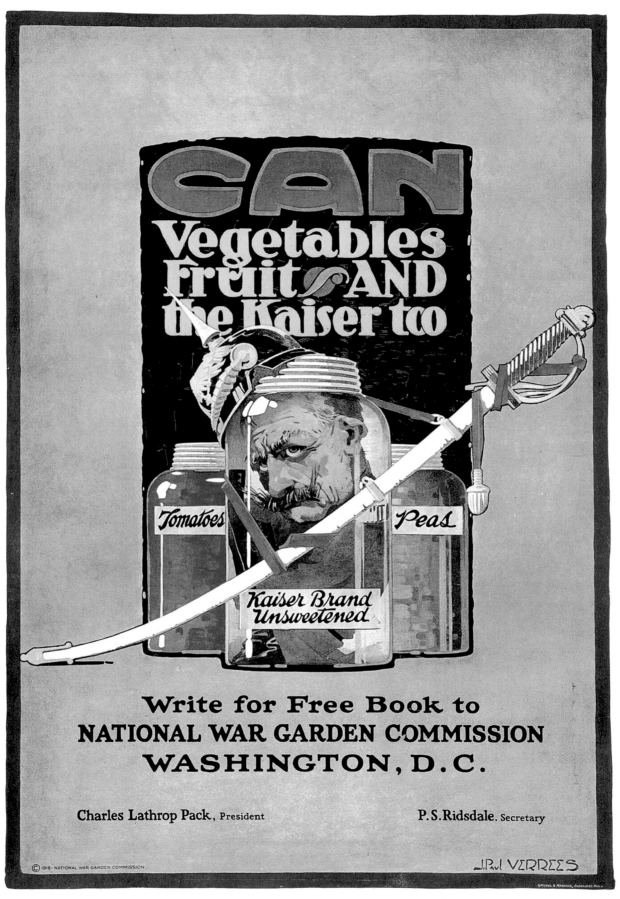

024. J. Paul Verrees, 1918

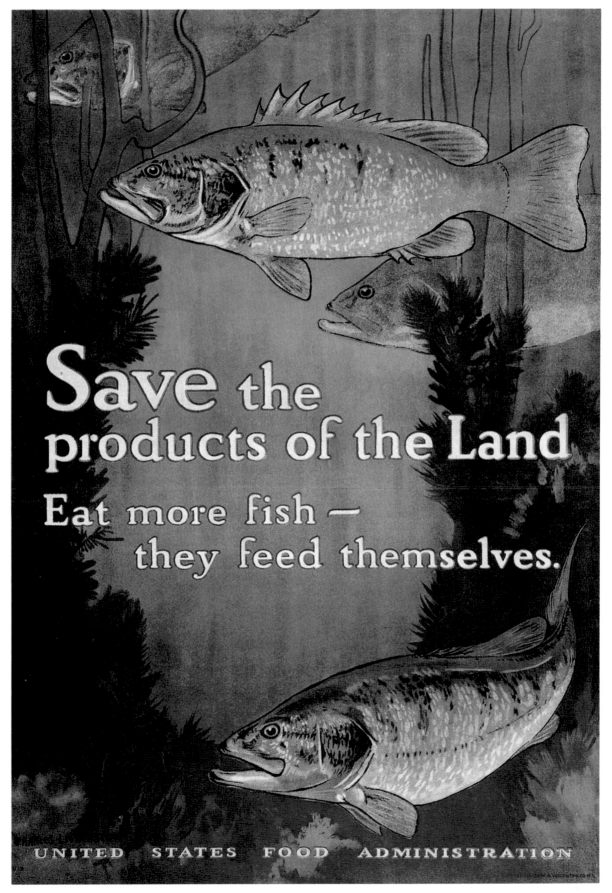

025. Charles Livingston Bull, 1918

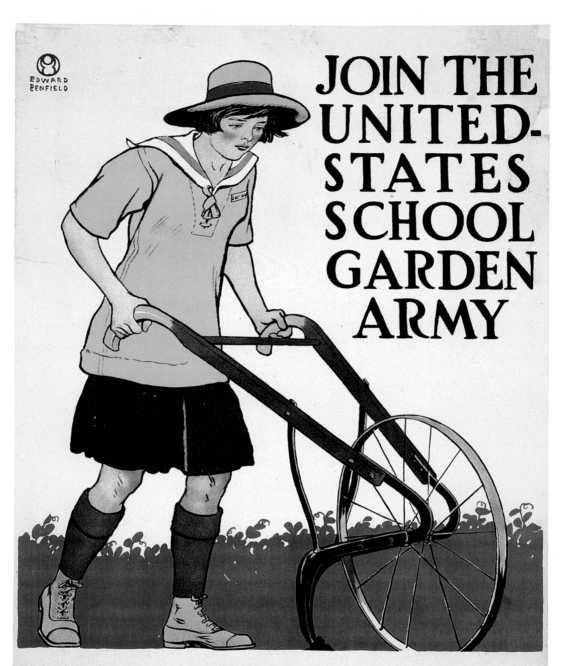

026. Edward Penfield, 1918

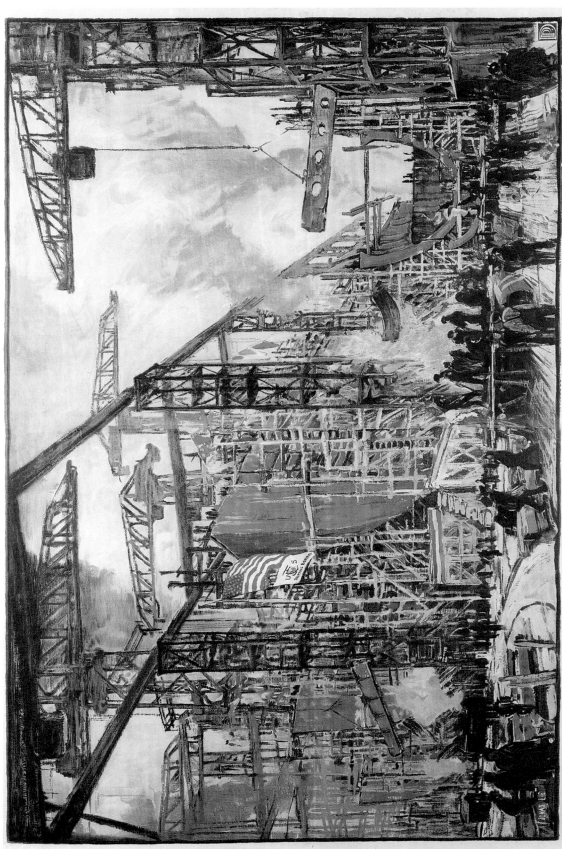

ON THE JOB FOR VICTORY

·UNITED STATES SHIPPING BOARD· EMERGENCY FLEET CORPORATION·

027. JONAS LIE, 1918

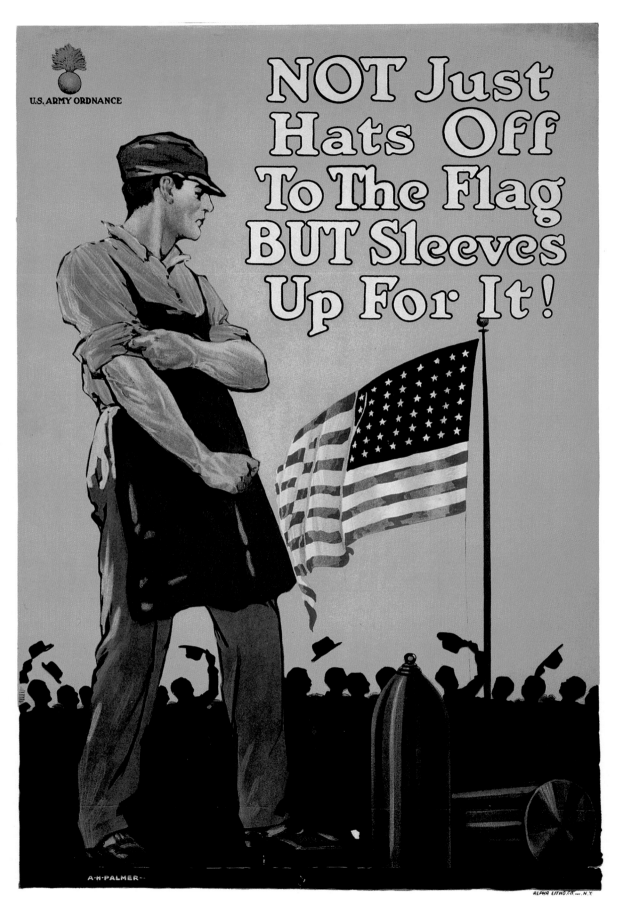

028. A. H. (Alfred Herbert) Palmer, 1917

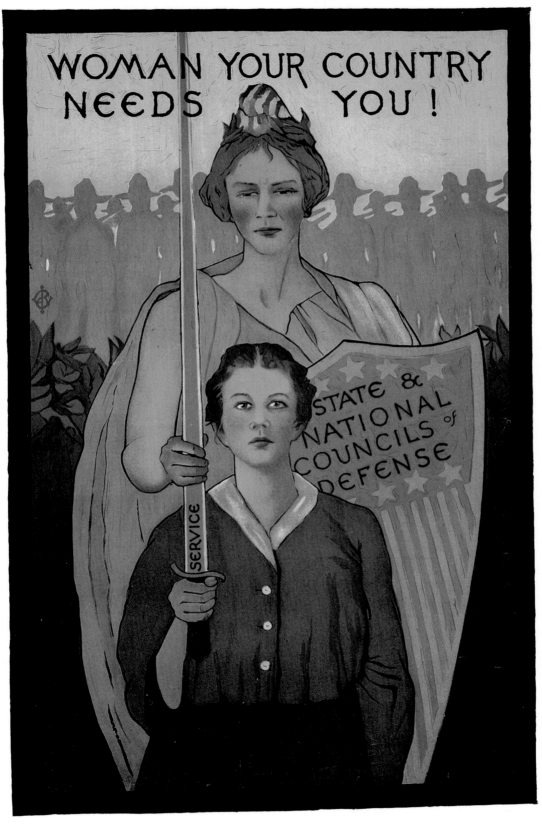

029. Artist Unknown, 1917

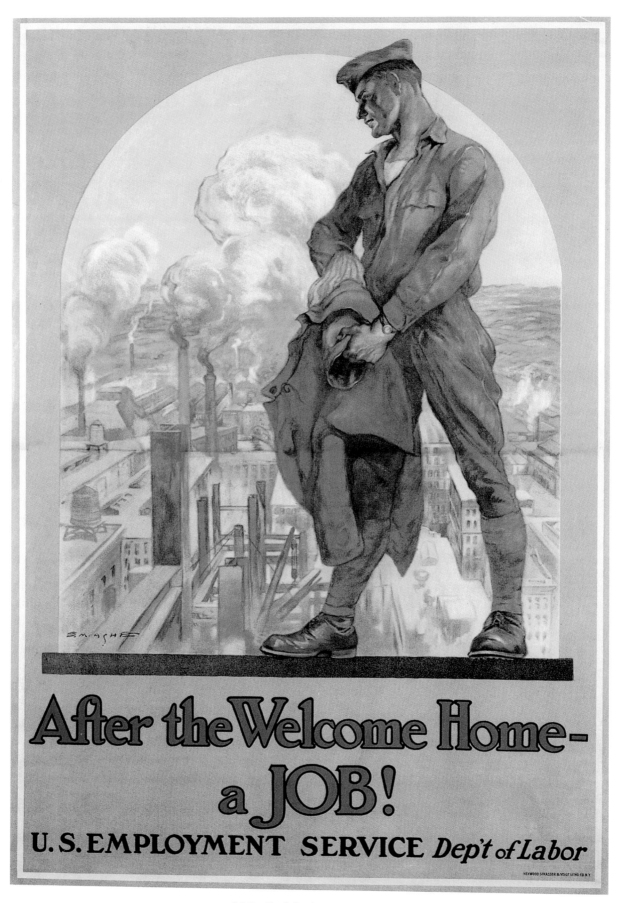

030. E. M. Ashe, 1919

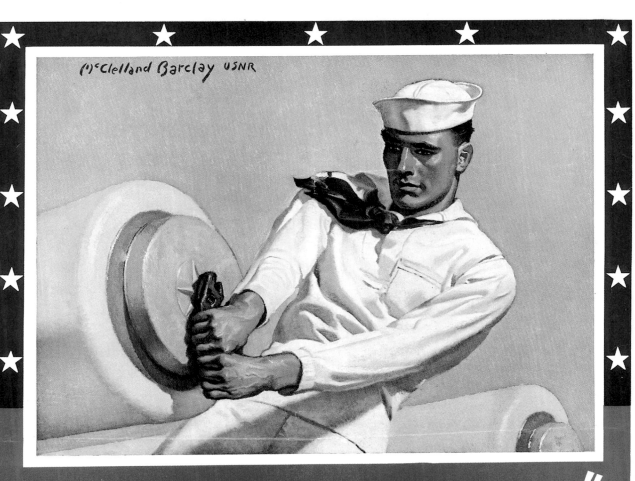

"ARISE AMERICANS"

Your Country and Your Liberty are in grave danger.. Protect them _now_ by joining the —

UNITED STATES NAVY or the U.S. NAVAL RESERVE

031. McClelland Barclay, n.d.

DISH IT OUT with THE NAVY!

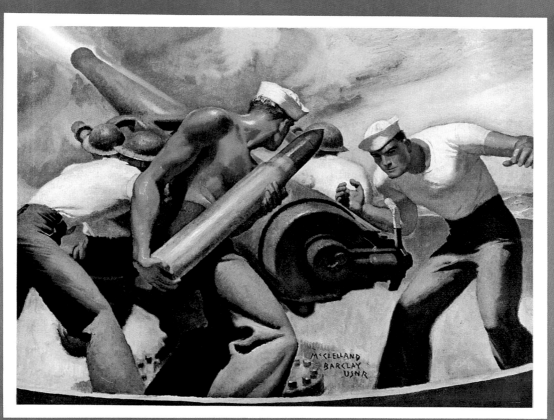

CHOOSE NOW WHILE YOU CAN

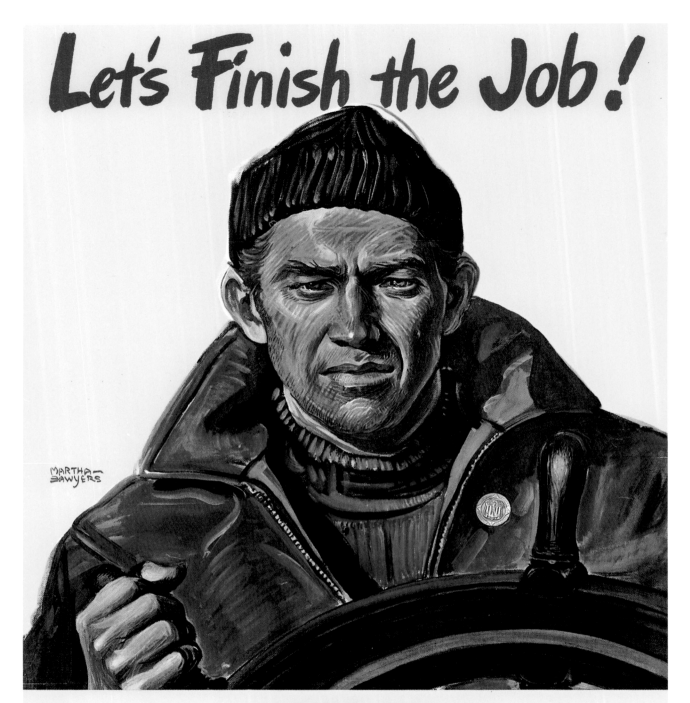

033. Martha Sawyers, n.d.

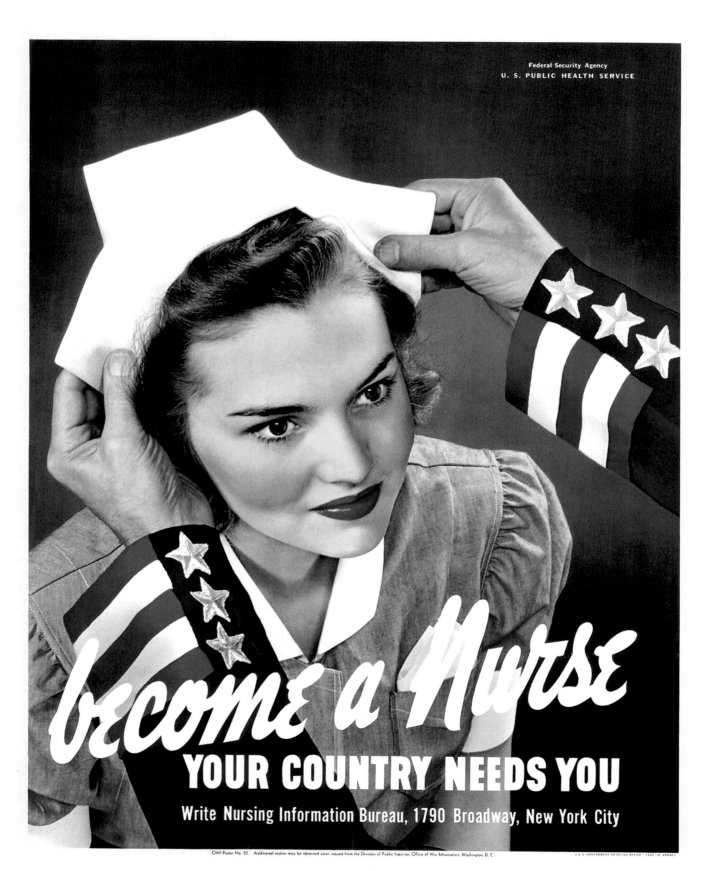

034. ARTIST UNKNOWN, 1942

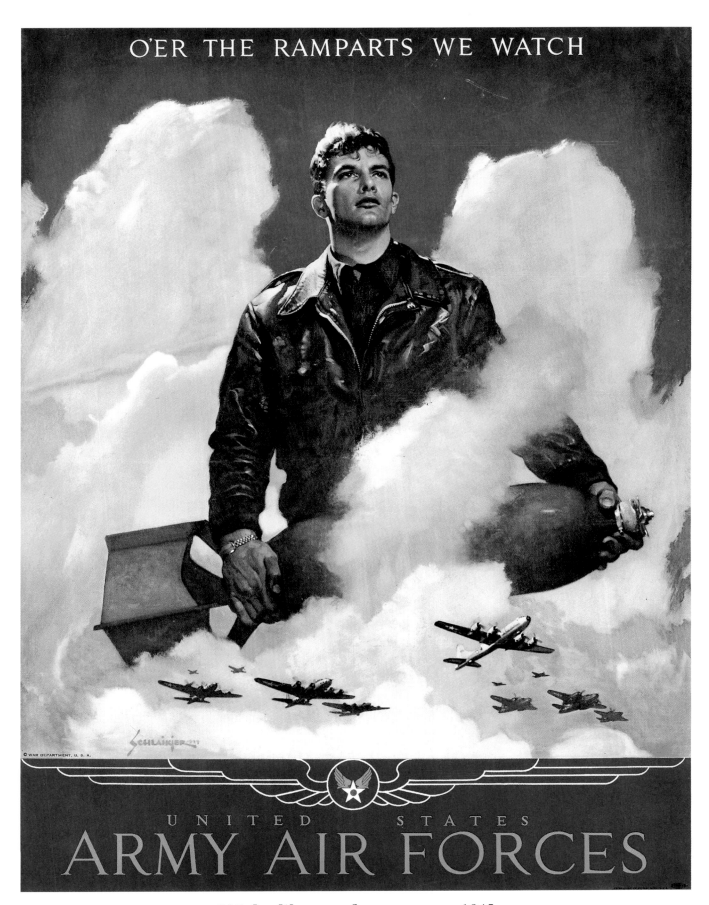

035. Jes Wilhelm Schlaikjer, c. 1945

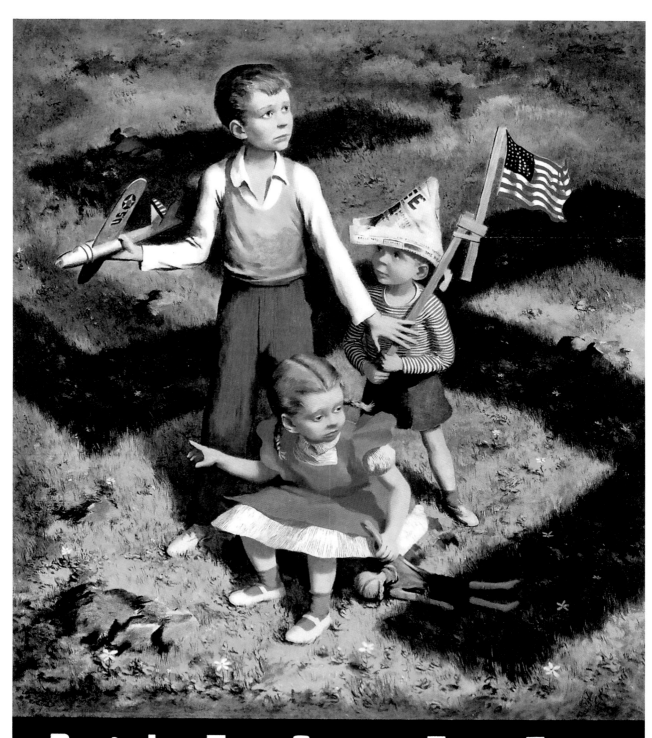

Don't Let That Shadow Touch Them

Buy **WAR BONDS**

036. Lawrence Beall-Smith, 1942

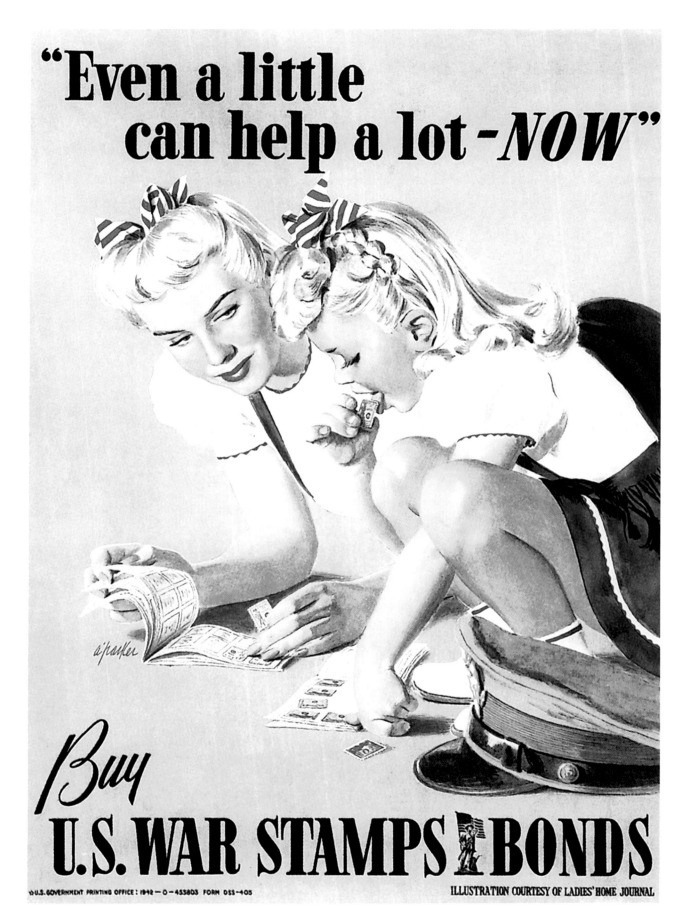

037. AL PARKER, 1942

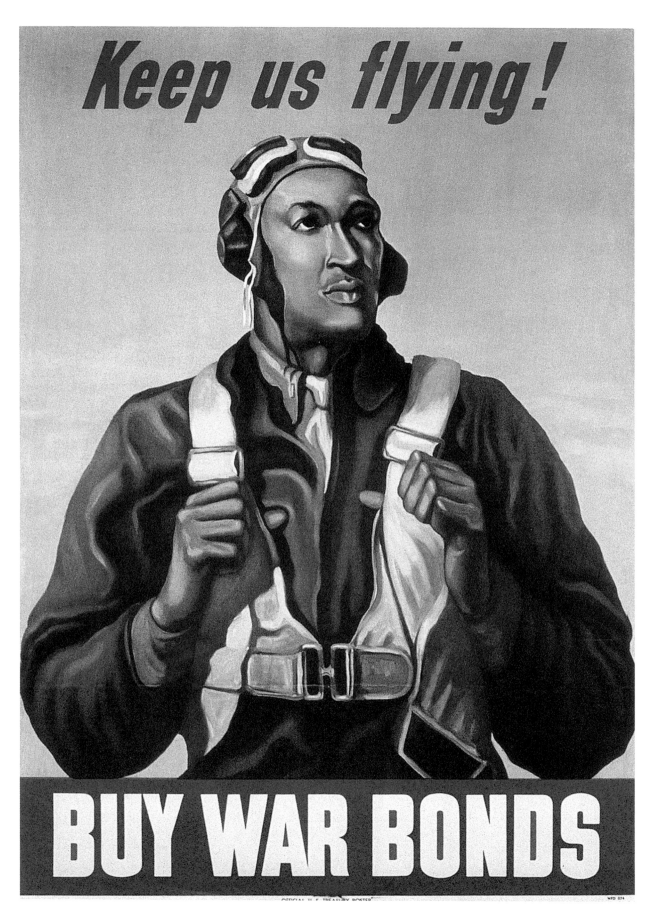

038. Artist Unknown, 1943

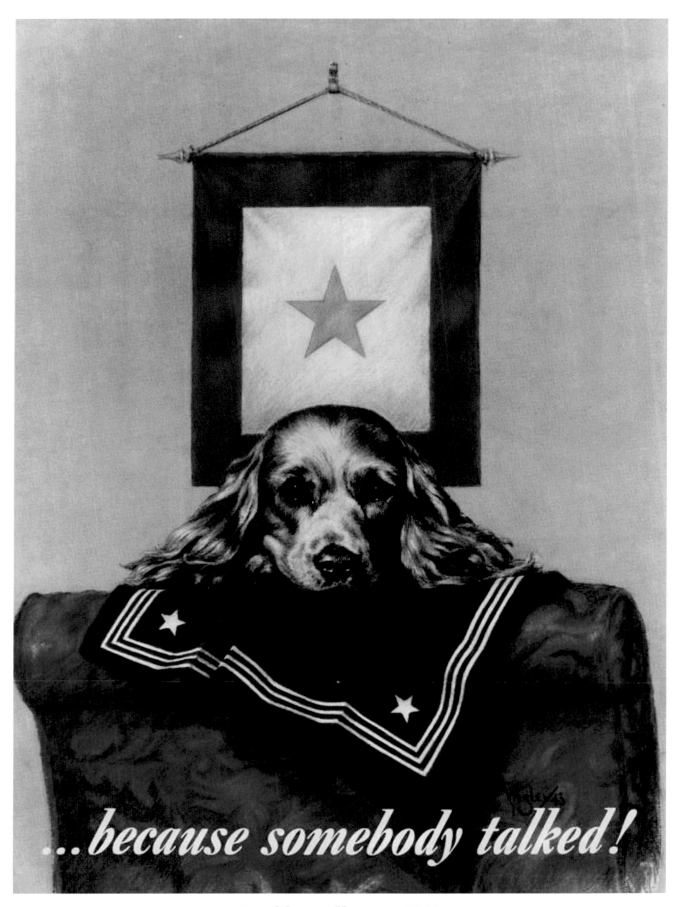

...*because somebody talked!*

039. WESLEY HEYMAN, 1944

040. ESSARGEE, N.D.

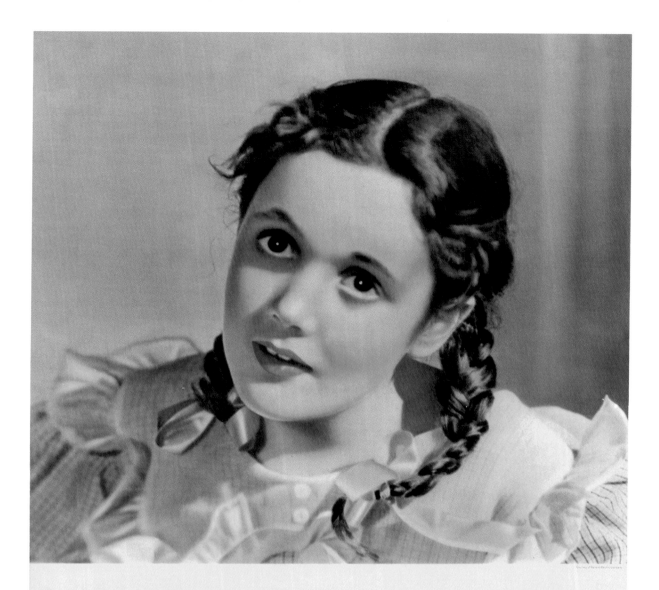

"...and God bless daddy and all the American workers who are doing so much to protect freedom and make this a better world for us to live in."

PRODUCE FOR VICTORY!

041. ARTIST UNKNOWN, 1942

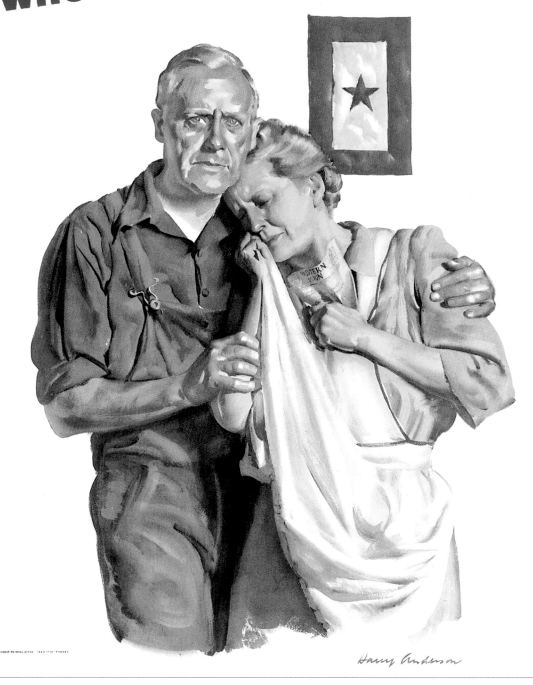

042. Harry Anderson, 1943

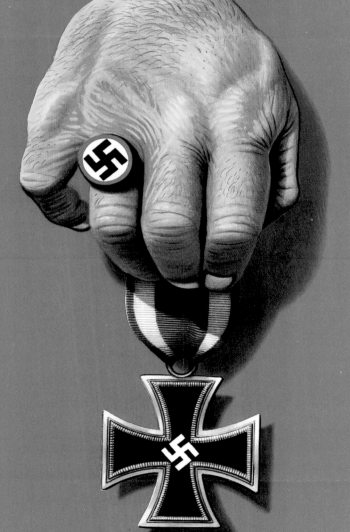

043. Stevan Dohanos, 1944

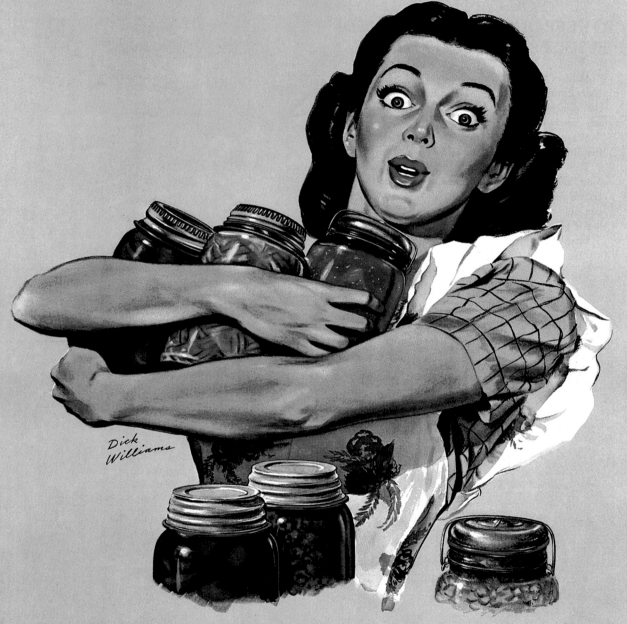

"OF COURSE I CAN!

I'm patriotic as can be —
And ration points won't worry me!"

WAR FOOD ADMINISTRATION
Washington, D. C.

044. DICK WILLIAMS, 1944

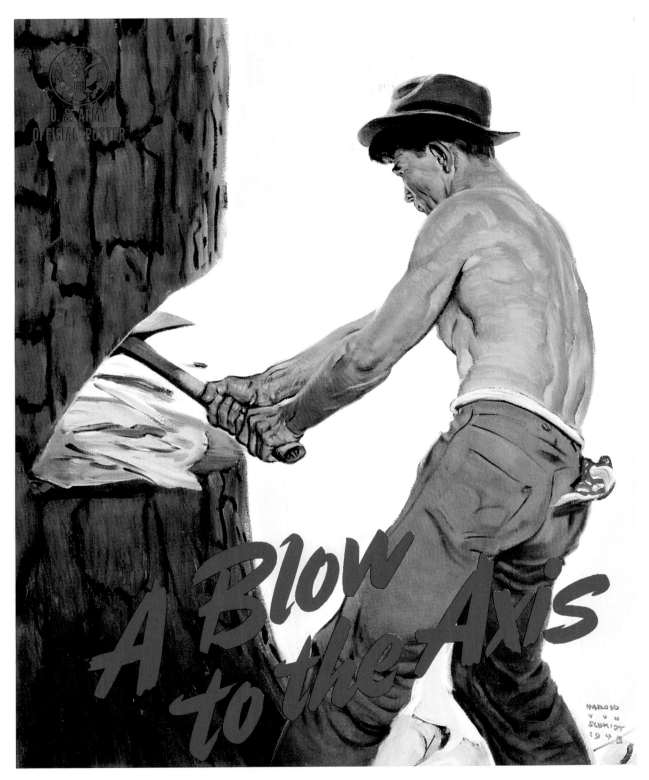

A Blow to the Axis

MORE LUMBER FOR THE ARMY

045. Harold Von Schmidt, 1943

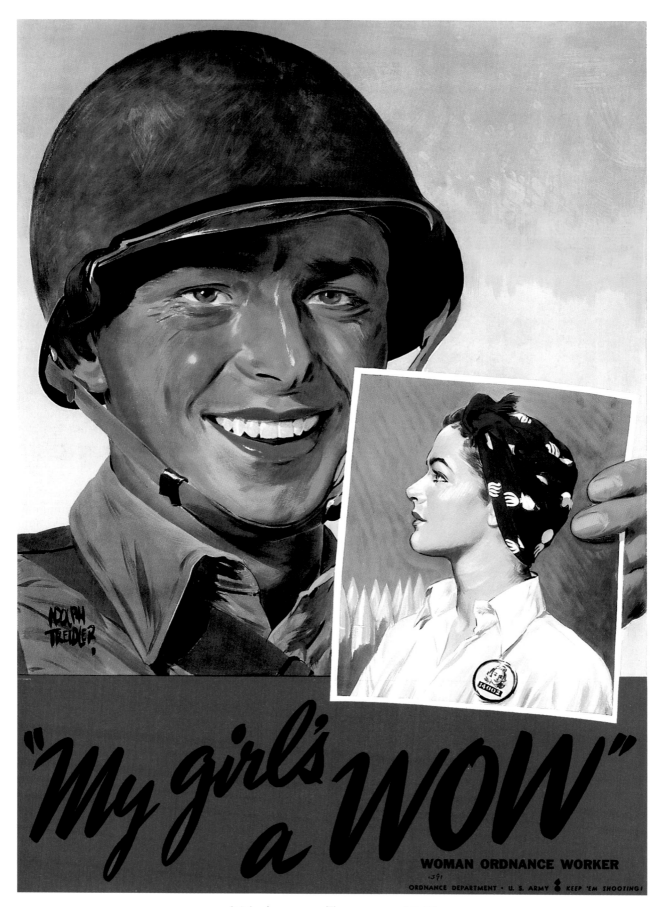

046. ADOLPH TREIDLER, 1943

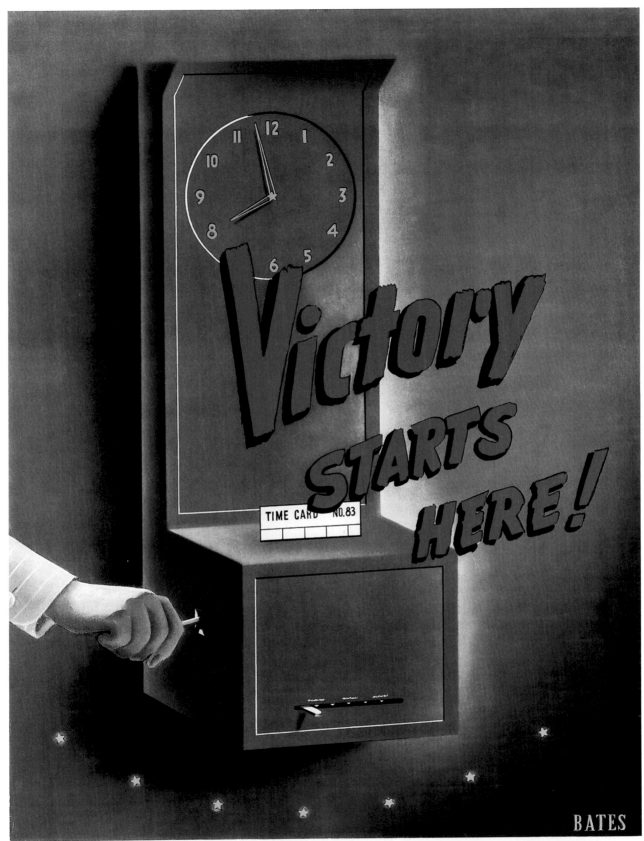

047. Bates, 1942

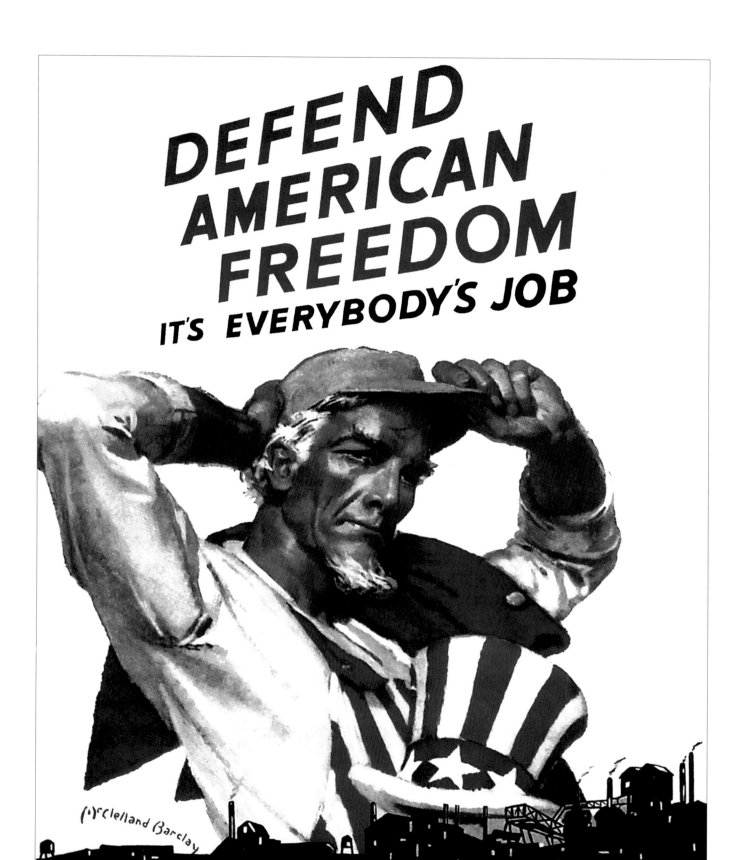

048. McClelland Barclay, 1942

049. Jean Carlu, 1942

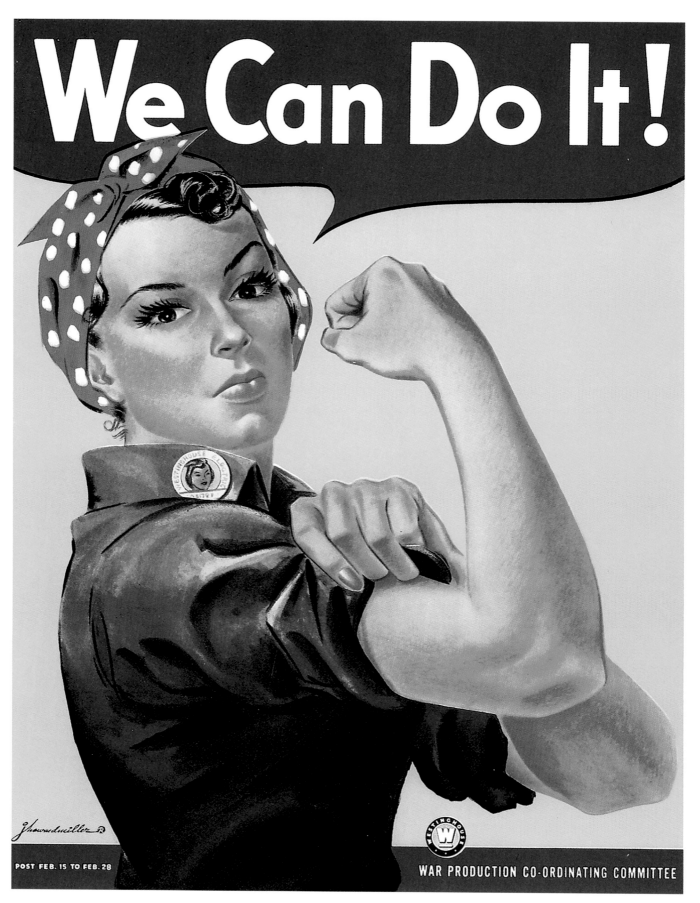

050. J. HOWARD MILLER, 1942

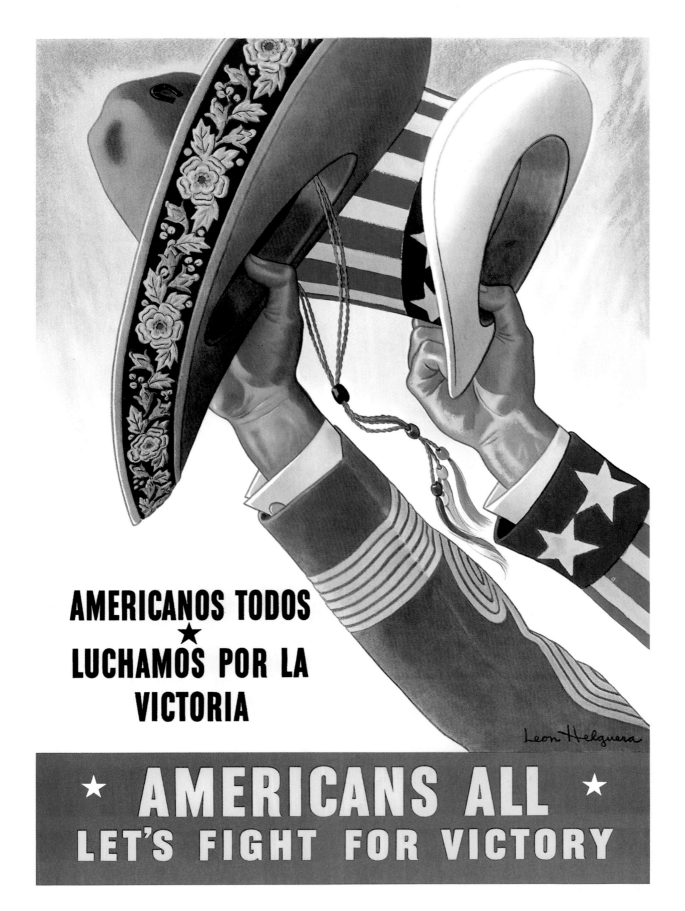

051. Leon Helguera, 1943

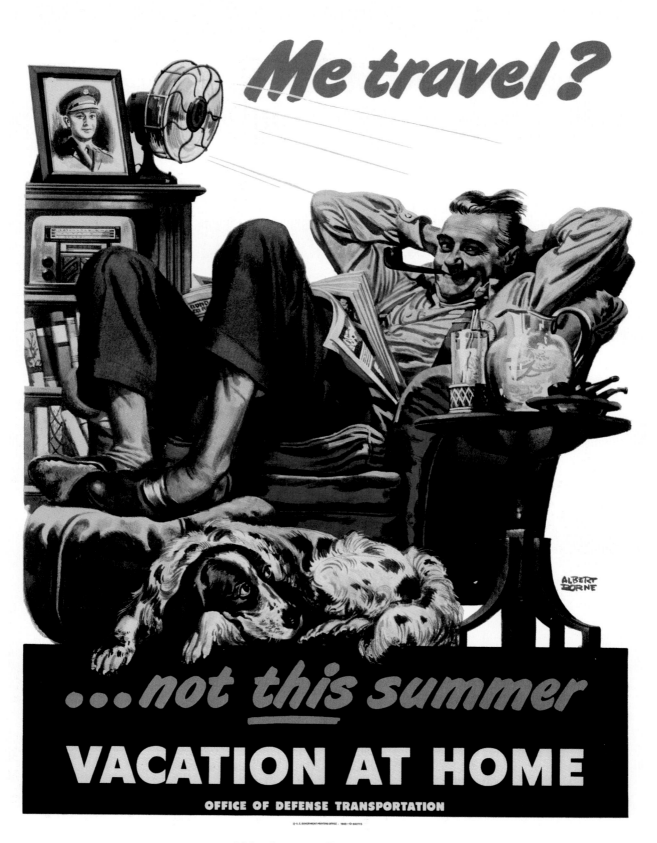

052. ALBERT DORNE, 1945

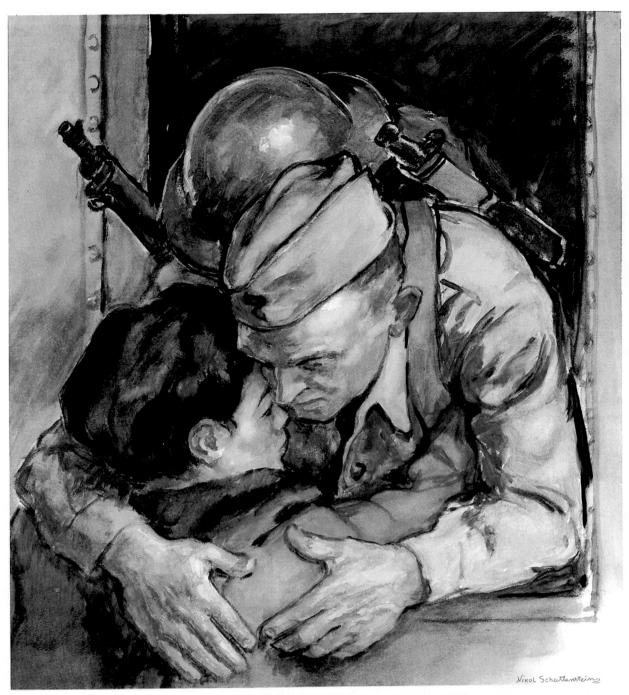

SACRIFICE
THE PRIVILEGE OF FREE MEN

WINNER INTERNATIONAL BUSINESS MACHINES CORP. AWARD — NATIONAL WAR POSTER COMPETITION
HELD UNDER AUSPICES OF ARTISTS FOR VICTORY, INC. — COUNCIL FOR DEMOCRACY — MUSEUM OF MODERN ART

REPRODUCED THROUGH COURTESY OF ARTISTS FOR VICTORY, INC., NEW YORK, N.Y. LITHOGRAPHED IN U.S.A. ON HOE SUPER-OFFSET PRESS BY GRINNELL LITHOGRAPHIC CO., NEW YORK, N.Y.

053. Nikol Schattenstein, n.d.

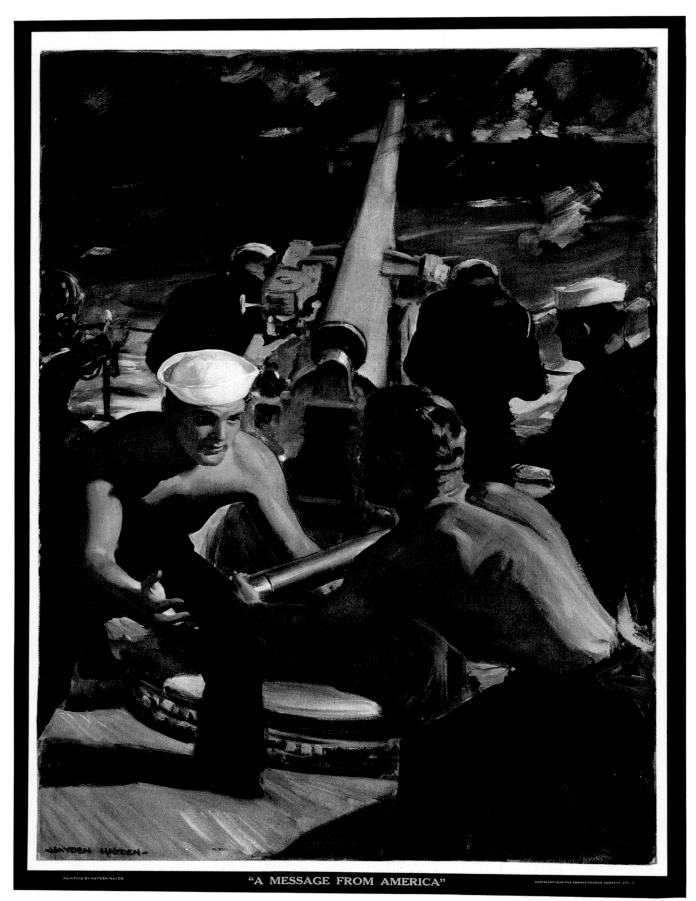

"A MESSAGE FROM AMERICA"

054. HAYDEN HAYDEN, 1943

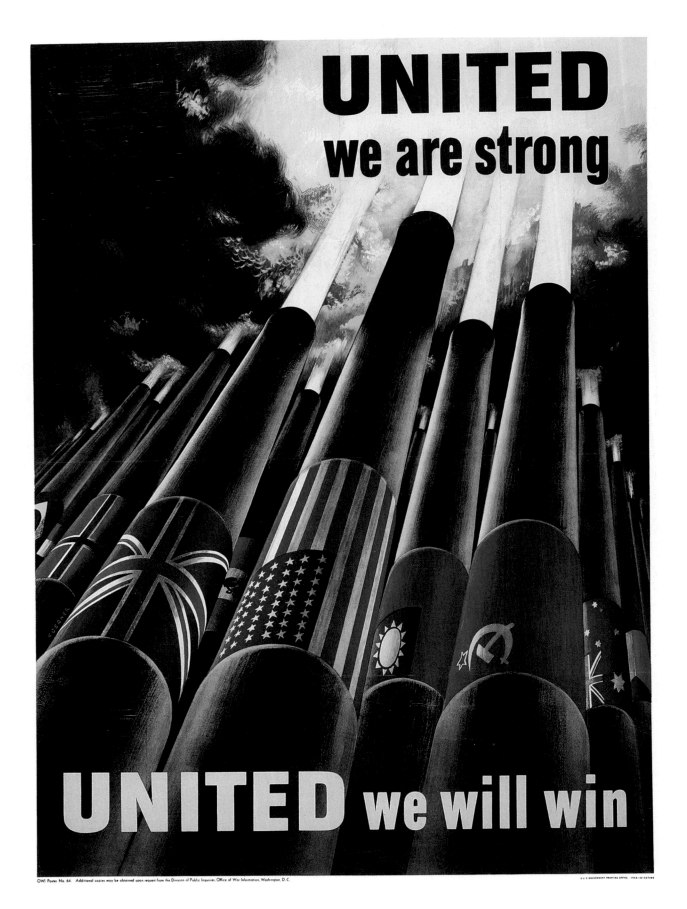

055. Henry Koerner, 1943

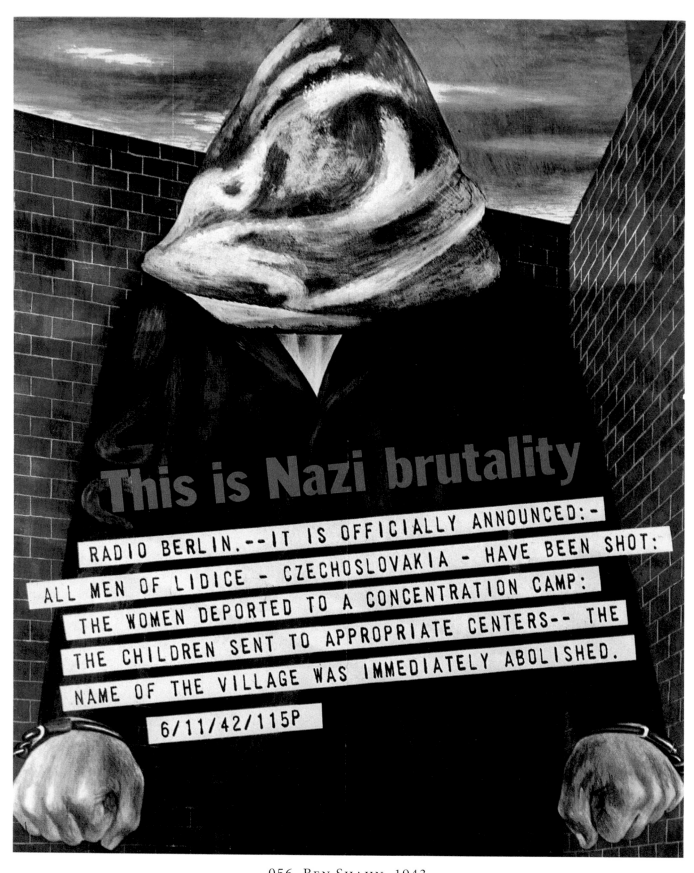

056. Ben Shahn, 1943

"THIS WORLD CANNOT EXIST HALF SLAVE AND HALF FREE"

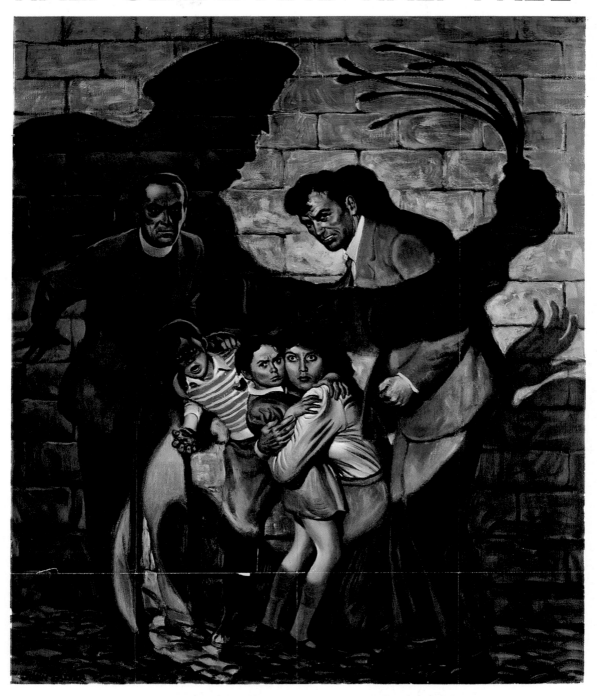

SACRIFICE FOR FREEDOM!

For additional copies write to Graphics Division, Office of Facts and Figures, Washington, D. C. . . . Specify GPO Jacket No. 453120.
U. S. GOVERNMENT PRINTING OFFICE. 1942—O

057. John Philip Falter, 1942

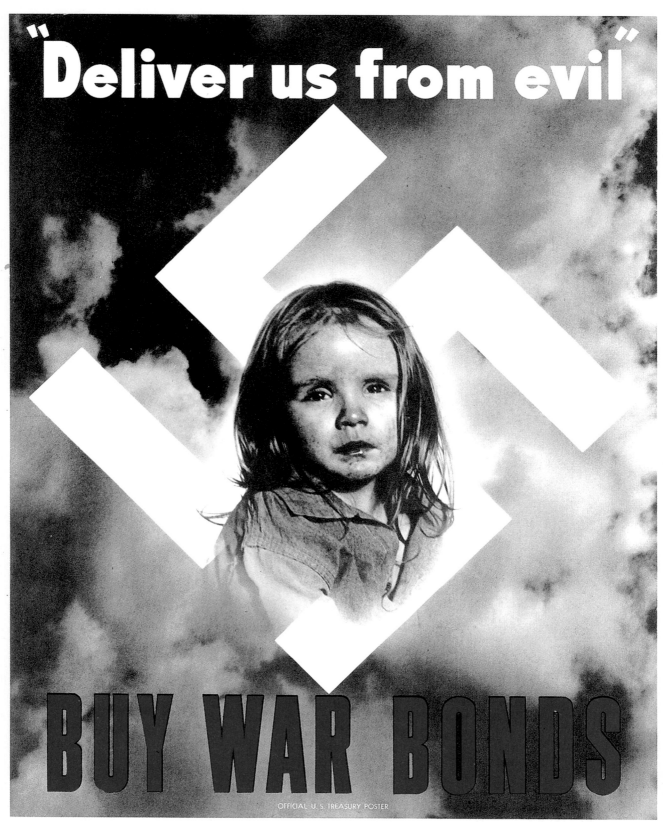

058. Harriet Nadeau, 1942

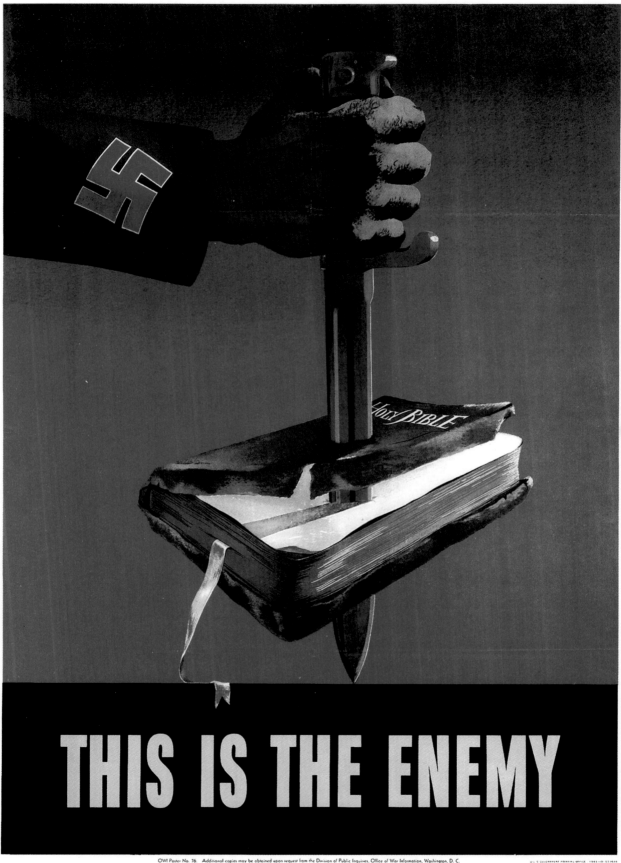

059. ARTIST UNKNOWN, 1943

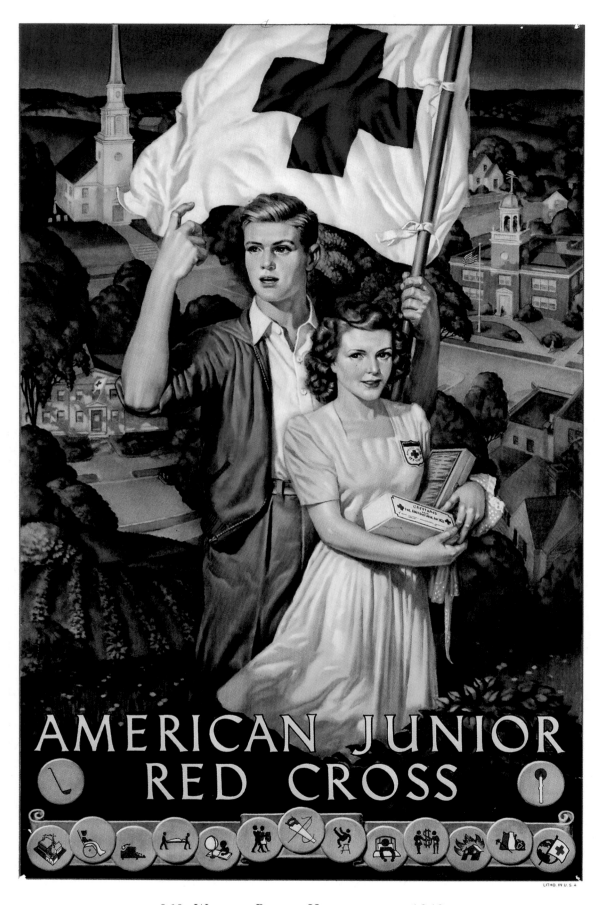

060. WALTER BEACH HUMPHREY, C. 1943

BIOGRAPHIES OF THE ARTISTS

Smith, Jessie Willcox. [Plate 001] 1863–1935. Born in Philadelphia, Smith was a student of the renowned artist Howard Pyle. She was prominent in the field of book illustration and was recognized for her magazine covers and her depictions of childhood.

Spear, Fred. [Plate 002] Artist information unavailable.

Christy, Howard Chandler. [Plate 003, bonus image 1] 1873–1952. This Ohio-born artist was known for his creation of the "Christy Girl," as well as for his paintings of American presidents and well-known public figures such as Will Rogers and Amelia Earhart and his depiction of the signing of the U.S. Constitution.

Flagg, James Montgomery. [Plate 004] 1877–1960. Forever recognized for his famous "Uncle Sam" *I Want You* poster [Plate 004], this New York artist designed many dozens of posters for the U.S. government. He produced illustrations for *Life* magazine as a teenager, and went on to portray Hollywood stars later in his career.

Leyendecker, Francis Xavier. [Plates 005, 013] 1877–1924. Francis "Frank" Leyendecker was the younger brother of the popular artist J. C. Leyendecker. Francis, a prolific illustrator, provided images for *Life, Vogue, Collier's,* and *Vanity Fair,* among other publications.

Paus, Herbert Andrew. [Plate 006] 1880–1946. A designer of books, including children's books, as well as posters and cartoons, Paus was known for his use of vivid colors.

Falls, Charles Buckles. [Plate 007, bonus image 2] 1874–1960. Born in Indiana but following his fortune to Connecticut and New York, Charles Buckles Falls included children's books in his illustration repertoire; he contributed color images and decorations to *The Goldenrod Fairy Book* (1903), and his woodcuts were used to make prints for *The Book of ABCs* (1923).

Babcock, Richard Fayerweather. [Plate 008] 1887–1954. After moving from his birthplace, Iowa, to Chicago, Fayerweather found success in providing illustrations for encyclopedias. An avid musician, he was a member of a chamber music ensemble.

Edrop, Arthur N. [Plate 009] In addition to his work on war posters, Edrop was known for drawing the American version of the Michelin Man. He was a frequent contributor to *The Saturday Evening Post.*

Hicks, Cornelius. [Plate 011] 1898–1930. The artist, born in Massachusetts, studied at Pratt Institute in New York City. He died at an early age of tuberculosis.

Emerson, Casper, Jr. [Plate 014] Artist information unavailable.

Pennell, Joseph. [Plate 015] 1857–1926. Raised in a Quaker family in Pennsylvania, Pennell was a friend of the artist James McNeill Whistler. He excelled at etching, and he provided illustrations for books written by his wife, Elizabeth Robins Pennell.

Wilson-Craig. [Plate 016] Artist information unavailable.

Ker. [Plate 017] Artist information unavailable.

Forsythe, Vic. [Plate 018] 1885–1926. The native Californian found great success with his comic strip "Joe Jinks." He worked for the Hearst papers, but he also turned to his love of the desert for artistic inspiration.

Orr, Alfred Everitt. [Plate 019] 1883–1962. Orr was born in New York City. After living in California, the painter moved into the London studio once occupied by John Singer Sargent. He gained renown for his portraits.

Nikolaki, Z. P. [Plate 020] [n.d.] Nikolaki was a well-known portrait painter; he also created cover illustrations for *The Saturday Evening Post.*

Waddell, M. [Plate 021] Artist information unavailable.

Verrees, J. Paul. [Plate 024] 1889–1942. This Belgian artist joined the American war effort by creating posters during World War I.

Bull, Charles Livingston. [Plate 025] 1874–1932. A native New Yorker, Bull did many illustrations for publications such as *The Saturday Evening Post, Life,* and *Collier's.* He enjoyed depicting animals and was an esteemed wildlife artist. His interest in animals led to his studies in taxidermy, and he became Chief Taxidermist at the National Museum in Washington, D.C.

Penfield, Edward. [Plate 026] 1866–1925. Born in New York, Penfield studied drawing and painting at the Art Students' League. He created illustrations for *Harper's* weekly and monthly editions, eventually becoming a full-time illustrator.

Lie, Jonas. [Plate 027] 1880–1940. The Norwegian-born artist later lived in Paris.

Palmer, A. H. (Alfred Herbert). [Plate 028] 1853–1931. Artist information unavailable.

Ashe, E. M. [Plate 030] 1867–1941. Ashe was a well-known illustrator of the early twentieth century. He was the head of the art department at Carnegie Tech (now Carnegie-Mellon) in Pittsburgh, Pennsylvania.

Barclay, McClelland. [Plates 031, 032, 048] 1891–1943. Barclay found a successful career in advertising art, providing images for clients such as General Motors ("Body by Fisher"). He also produced covers for *Ladies' Home Journal* and *Redbook.* In addition to his illustration work, he was a gifted designer of costume jewelry and other decorative objects. Barclay was killed in action during World War II.

Sawyers, Martha. [Plate 033] 1902–1988. Sawyers was known for the excellence of her multicultural imagery. She illustrated a serialization of Pearl S. Buck's work *China Gold.*

Schlaikjer, Jes Wilhelm. [Plate 035] 1897–1982. Schlaikjer grew up in South Dakota, and his artistic skill led to produce cartoons for a local newspaper. He studied at the Chicago Art Institute and produced illustrations for many national magazines, as well as providing cover art for *American Legion* magazine.

Beall-Smith, Lawrence. [Plate 036] 1909–c. 1995. Skilled as a painter, lithographer, and sculptor, Beall-Smith found great

renown after his one-man show at the Whitney Museum in New York. A number of his works are in the art collection of the U.S. Department of the Navy.

Parker, Al. [Plate 037] 1906–1985. Parker created the winning cover illustration for a *House Beautiful* competition; he went on to illustrate covers for many national magazines. His artwork was highly influential from the 1940s through the 1960s.

Heyman, Wesley. [Plate 039] ? – 2002. Artist information unavailable.

Essargee. [Plate 040] Essargee was the pseudonym of Henry Sharp Goff, Jr.

Anderson, Harry. [Plate 042] 1906–1996. A Chicagoan by birth, Anderson was active in advertising and magazine illustration from the 1930s through the 1980s. His high-profile clients included Wyeth Pharmaceuticals, Ovaltine, and Buster Brown shoes. Anderson was known for his deft storytelling skills and effective use of light in his imagery.

Dohanos, Stevan. [Plate 043] 1907–1994. In addition to creating numerous *Saturday Evening Post* covers depicting various facets of American life, Dohanos used his artistry to design several dozen U.S. postage stamps.

Williams, Dick. [Plate 044] [n.d.] Williams produced many portraits throughout his career. He created advertising art and magazine illustrations during the 1940s and 1950s and was known for depicting post–World War II American life.

Schmidt, Harold Von. [Plate 045] 1893–1982. Born in California, Von Schmidt was orphaned as a child and raised by his grandfather, who entertained him with tales of the American West. Many of the artist's images were derived from these early impressions. Von Schmidt produced book illustrations and magazine work, often using oils and working on large canvases. As a war correspondent, he was able to use his artistic skills to create accurate portrayals of wartime scenes.

Treidler, Adolph. [Plate 046] 1886–1981. Treidler made posters for both World Wars I and II. His artistic career included fashion illustration, images for the Pierce-Arrow automobile, and magazine covers. His promotional pieces for the Bermuda trade board in 1930 helped increase tourism to the island.

Bates. [Plate 047] Artist information unavailable.

Carlu, Jean. [Plate 049] 1900–1997. This French graphic artist designed posters for the World War II war effort while living in the United States. His artwork was influenced by Art Deco and Cubism. Several of his prints were acquired by the Smithsonian American Art Museum.

Miller, J. Howard. [Plate 050] 1918–2004. Perhaps the most significant aspect of Miller's creation of World War II posters was his depiction of the strong, confident woman in *We Can Do It*, a reference to the iconic American heroine Rosie the Riveter.

Helguera, Leon. [Plate 051] 1899–1970. The Mexican-born artist, in addition to his illustration work, was one of the foremost postage stamp designers of the 1930s and 1940s. He created the first stamps for the United Nations.

Dorne, Albert. [Plate 052] 1906–1965. Dorne, born in New York City, studied lettering and then worked in a commercial art studio. As a freelance illustrator, he was well known for his contributions to *Life* and *The Saturday Evening Post,* among other prominent national publications. In 1948, Dorne founded the Famous Artists School, offering correspondence courses in art.

Schattenstein, Nikol. [Plate 053] 1877–1954. Born in Russia, Nikol Schattenstein was highly regarded in Europe as a portrait painter. He continued his portrait work in the United States; especially noteworthy was his portrayal of the writer H. L. Mencken.

Hayden, Hayden. [Plate 054] 1885– ? Hayden Hayden was the pseudonym of Howard Crosby Renwick. The artist was known for his pin-ups, but he also produced advertising art for clients such as Jell-O, Arrow shirts, Coca-Cola, and Beech-Nut gum.

Koerner, Henry. [Plate 055] 1915–1991. The Austrian-born illustrator found great success creating cover illustrations for *Time* magazine. Among his subjects were Maria Callas, Leonard Bernstein, and Senator John Kennedy; he also depicted the Vietnam War.

Shahn, Ben. [Plate 056] 1898–1969. Leaving Lithuania to settle with his family in Brooklyn as a child, Shahn went on to become one of the most notable American illustrators of the twentieth century. He studied lithography and graphic design and strove to create realistic art with political content. After producing images for the Office of War Information in the 1940s, Shahn turned to commercial art and teaching.

Falter, John Philip. [Plate 057; bonus image 8] 1910–1982. The Nebraska native discovered that his early attempts at comic art paid off, and he went on to pursue a successful career in illustration and advertising art. His clients included Gulf Oil and Arrow shirts. He also made portraits of Hollywood stars and jazz musicians. Falter enlisted in the Navy in 1943 and used his artistry to create more than 300 recruitment posters.

Nadeau, Harriet. [Plate 058] Artist information unavailable.

Humphrey, Walter Beach. [Plate 060] 1892–1966. Born in Wisconsin, Humphrey eventually moved to New York, where he became a successful illustrator. Some of his work showed the influence of the Art Deco style. Early in his career he shared studio space with Norman Rockwell.

Kline, Hibberd. [bonus image 5] 1885– ? Hibberd V. B. Kline was born in New York. His artistic strengths were in illustration, etching, and painting. Kline created many magazine covers and taught art at Syracuse University in New York.

Kroger. [bonus image 6] Artist information unavailable.

Sloan, Robert Smullyan. [bonus image 7] b. 1915. Artist information unavailable.

Winslow, Earle. [bonus image 9] 1884–1969. Winslow was an accomplished painter, book illustrator, and lithographer. One of his assignments was to create posters for the U.S. Forest Service Smokey Bear campaign. He lived in Woodstock, New York.

Whitman. [bonus image 10] Artist information unavailable.

ALPHABETICAL LIST OF WORKS

After the Welcome Home—A Job! (Ashe) [030]

American Junior Red Cross (Humphrey) [060]

Americans All (Helguera) [051]

Americans Suffer When Careless Talk Kills! (Anderson) [042]

America's Answer! Production (Carlu) [049]

[and] God Bless Daddy (Artist unknown) [041]

And They Thought We Couldn't Fight (Forsythe) [018]

"Arise Americans" (Barclay) [031]

Award for Careless Talk (Dohanos) [043]

Because Somebody Talked (Heyman) [039]

Become a Nurse (Artist unknown) [034]

Blow to the Axis, A (Von Schmidt) [045]

Can Vegetables, Fruit and the Kaiser Too (Verrees) [024]

Defend American Freedom (Barclay) [048]

Deliver Us from Evil (Nadeau) [058]

Dish It Out With the Navy (Barclay) [032]

Doing All You Can? (Sloan) [bonus image 7]

Don't Let That Shadow Touch Them (Smith) [036]

E-E-E-Yah-Yip Go Over With Marines (Falls) [007]

Enlist (Spear) [002]

"Even a Little Can Help a Lot—Now" (Parker) [037]

Every American Boy Should Enroll (Artist unknown) [022]

For Home and Country (Orr) [019]

For Liberty's Sake (Artist unknown) [010]

For the Safety of Womanhood (Ker) [017]

Gee! I Wish I Were a Man (Christy) [003]

Harriman National Bank Urges, The (Waddell) [021]

Have YOU a Red Cross Service Flag? (Smith) [001]

Hello! This Is Liberty Speaking (Nikolaki) [020]

Help Them (Emerson) [014]

Hun Is Still Watching, The (Artist unknown) [bonus image 4]

If You Tell Where He's Going (Falter) [bonus image 8]

If You Want to Fight (Christy) [bonus image 1]

I Want YOU for U.S. Army (Flagg) [004]

Join Me (Falls) [bonus image 2]

Join the Navy (Babcock) [008]

Join the United States School Garden Army (Penfield) [026]

Keep Him Off Your Street (Kroger) [bonus image 6]

Keep That Lumber Coming (Winslow) [bonus image 9]

Keep Us Flying! (Artist unknown) [038]

Let's Finish the Job! (Sawyers) [033]

Loose Lips Might Sink Ships (Essargee) [040]

Make the World Safe (Edrop) [009]

Message from America, A (Hayden) [054]

Me Travel? (Dorne) [052]

My Daddy Bought Me a Gov't. Bond (Artist unknown) [bonus image 3]

"My Girl's a Wow" (Treidler) [046]

1918 Spring Drive Liberty Loan (Wilson-Craig) [016]

Not Just Hats Off to the Flag (Palmer) [028]

O'er the Ramparts We Watch (Schlaikjer) [035]

Of course I can! (Williams) [044]

On the Job for Victory (Lie) [027]

Our Greatest Mother—Join! (Hicks) [011]

Over There (Artist Unknown) [012]

Sacrifice (Schattenstein) [053]

Save the Products of the Land (Bull) [025]

Teamwork Wins (Kline) [bonus image 5]

10,000,000 Members by Christmas (Artist unknown) [023]

That Liberty Shall Not Perish (Pennell) [015]

These Men Have Come Across (Leyendecker) [005]

This Is the Enemy (Artist unknown) [059]

This Is Nazi Brutality (Shahn) [056]

This World Cannot Exist (Falter) [057]

United States Army Builds Men, The (Paus) [006]

United We Are Strong (Koerner) [055]

U.S.A. Bonds—Weapons for Liberty (Leyendecker) [013]

Victory Starts Here! (Bates) [047]

We Can Do It! (Miller) [050]

Woman Your Country Needs You! (Artist unknown) [029]

Your Blood Can Save Him (Whitman) [bonus image 10]

BONUS IMAGES

See the link in the "Info" folder on the DVD
to download your bonus images.

1

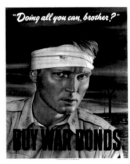

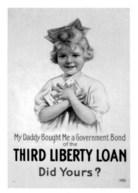

3

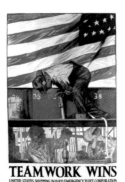

5

1. HOWARD CHANDLER CHRISTY, 1915
(1873–1952)
If You Want to Fight

2. CHARLES BUCKLES FALLS, 1917
(1874–1960)
Join Me

3. ARTIST UNKNOWN, 1917
My Daddy Bought Me a Government Bond

4. ARTIST UNKNOWN, 1917
The Hun Is Still Watching

5. HIBBERD KLINE, 1918
1885– ?
Teamwork Wins

6. KROGER, 1942
[n.d.]
Keep Him Off Your Street

7. ROBERT SMULLYAN SLOAN, 1943
(b. 1915)
Doing All You Can?

8. JOHN PHILIP FALTER, 1943
(1910–1982)
If You Tell Where He's Going

9. EARLE WINSLOW, 1943
(1884–1969)
Keep That Lumber Coming

10. WHITMAN, 1945
[n.d.]
Your Blood Can Save Him

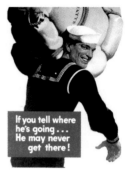

6

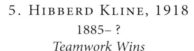

7

8

9

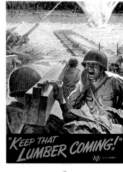

10

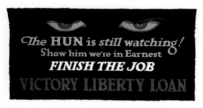

2

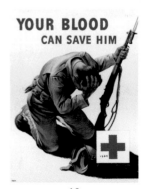

4